RYSZARD KAPUŚCIŃSKI

Nobody Leaves

Impressions of Poland

Translated by William R. Brand

PENGUIN BOOKS

PENGUIN CLASSICS

UK | USA | Canada | Ireland | Australia
India | New Zealand | South Africa

Penguin Books is part of the Penguin Random House group of companies
whose addresses can be found at global.penguinrandomhouse.com

Penguin
Random House
UK

First published in Poland under the title *Busz po polsku* by Czytelnik,
Warsaw, 1962
This translation published in Penguin Classics 2017
001

Original text copyright © Ryszard Kapuściński, 1962
Translation copyright © William R. Brand, 2017

The moral right of the translator has been asserted

Set in 11.2/13.9 pt Dante MT Std
Typeset by Jouve (UK), Milton Keynes
Printed in Great Britain by Clays Ltd, St Ives plc

A CIP catalogue record for this book is available from the British Library

ISBN: 978–1–846–14360–1

Contents

Translator's Note

In 1959, when he turned twenty-seven, Ryszard Kapuściński had already been abroad as a reporter. In that year, he went to work for the weekly *Polityka*, which sent him into the field as a domestic correspondent between brief assignments in Africa. His stories appeared at irregular intervals, often on the front page. In annual polls, the paper's readers picked Kapuściński as their favourite writer on a staff filled with journalists who would dominate the Polish media over the following decades.

The Poland that Kapuściński was reporting on was, from our perspective today, as 'exotic' as any of the Third World countries he covered. He liked to point out its similarities to new states throwing off colonialism or struggling through major social conflicts. Poland had suffered destruction and Nazi occupation in the Second World War less than two decades earlier, and was still rebuilding. Compromises between Roosevelt, Churchill and Stalin led to the imposition of communist rule. The country's borders shifted – Kapuściński's own birthplace ended up in the Soviet Union, while Poland absorbed territory that had long been German.

Polish Stalinism ended with the 'thaw' of 1956. A new leadership released political prisoners, eased censorship, and won fleeting popularity with gestures of assertiveness towards the Soviet overlords. People had barely begun exploring this lessening of restrictions when the Party started tightening the screws again, leading by the time these pieces were written to a 'minor stabilization' that attempted to compensate for diminished freedom with modest improvements to the standard of living.

Most Poles hated this alien system they were fated to live under

and did not hesitate to say so in private. But such views could hardly be expressed in public, let alone in the press.

The official narrative never deviated from Soviet-style orthodoxy. Its themes were outside threats (in particular 'German revanchism' – American-backed West Germany was now a NATO 'warmonger' with a shameful Nazi past, and worst of all it refused to recognize the transfer of German territory to Poland), progress (Sputnik of course, but also domestically produced automobiles or at least motorbikes, and the electrification of the poverty-stricken countryside), and the topic that never went out of style, industrialization and the benefits it supposedly brought to the populace.

The ruling party claimed that history was on its side, and the country would prosper if only everyone joined the collective effort under its stewardship. There were holdouts, but they were denounced as a Catholic, nationalistic element that would fade away as successive waves of young people came on the scene and joined in constructing a bright future.

How did Kapuściński, an emerging star reporter for one of the regime's leading opinion-shaping organs, write about this Poland?

He turned almost everything on its head. He sought out people who had been bypassed by the new order, or who refused to join in.

Instead of writing about the new factories and housing developments, he journeyed to remote parts of the country, to run-down villages that had been practically medieval a few years earlier or towns taken over from the expelled Germans. In 'The Fifth Column on the March' he discovers an elderly German mother and daughter stranded since the end of the war in a Polish old people's home. When they happen to catch a West German broadcast on the radio, they believe that the Reich has risen again and set out to reclaim their confiscated property. This is a burlesque of official propaganda about resurgent German militarism.

'A Farmer at Grunwald Field' recounts a visit to the site of the 1410 Battle of Grunwald, a victory by the Polish Commonwealth

over the Teutonic Knights and the occasion for an annual propaganda extravaganza. The farmer Kapuściński talks to does not know or care what all the fuss is about. He is concerned about his crops.

Penurious university lecturers riding a train to the lake country in 'A Survivor on a Raft' glance uneasily out of the window at private cars and motorbikes carrying the more fortunate beneficiaries of the Minor Stabilization.

'On the Ground Floor' does have to do with the industrial boom – but only in the sense that its vagabond characters scorn the game everyone else seems to be playing. The university dropouts of 'No Known Address' represent another variation on abnegation as a chosen lifestyle. The protagonist of 'The Geezer', once an enthusiastic activist, is burned out after all the political shifts of the past decade, and the title character of 'The Loser' renounces consumerist ambitions and retreats into a kind of proto-beatnik serenity. 'Nobody Leaves' and 'The Taking of Elżbieta' depict existential hells that no ideology or ruling party could ever alleviate.

How did he get away with focusing on individual dilemmas and alienation so at odds with the Party's image of the society it claimed to be building? Kapuściński was far from being any kind of dissident. He was doing his job. Reporters under communism were not expected to be mere stenographers recapitulating Party edicts. Nor were they supposed to be 'objective' if that meant ignoring potential causes of public discontent. In her 1990 study *Poland's Journalists: Professionalism and Politics*, researched before the fall of the old system, the American sociologist Jane Leftwich Curry notes that the press was 'something like a "British loyal opposition"', a watchdog to ensure that policy was implemented properly. Moreover, she writes, it was normal for journalists to have connections among the ruling apparatus, and to use those contacts to influence policy.

Thus it is that in 'The Dune', when the collective farm faces bankruptcy, the reporter/narrator steps in with an offer to 'finagle the money out of the county administration'. In 'Danka', he parodies a semi-literate policeman and a bombastic local Party

boss who are incapable of dealing with an outbreak of faith-based violence.

Kapuściński's main focus, however, is not on himself or his role. These are stories about the people he encounters. He sometimes pokes fun at their foibles, but never withholds his empathy. The way many of them have deliberately cut themselves off from the big worlds of ideology and consumerism accentuates their humanity. Some of them are trapped. Most of them, however, have – or had – a chance to shape their own fate, to make something of themselves. Many have squandered that chance, or never even noticed it when it came along. They become spectators, extras, losers, outsiders who will never rise above the ground floor. These are existential moments caught in a philosophical spotlight.

The discus-thrower in 'The Big Throw' knows how to seize his chance. The pallbearers in 'The Stiff' manage to form a functional collective, but only because there is no other way out, not as a response to directives from above.

Beyond these stories of individual choice, Kapuściński revels in his descriptive abilities, his ear for speech, and the earthiness of the country he is reporting on. 'City people don't know that you can sniff the soil. And it had a smell. "Soir de Paris".' His villagers might have terrible taste or an aversion to toothpaste, but there is something exuberant about the way they buzz around their fields on motorbikes, show off their wristwatches, or board the new Torpedo train. Here, at least, Kapuściński discerns the progress made since his own grim boyhood. He can see through the eyes of his subjects and feel how their own lives feel to them. Immersing himself in the back corners of his homeland, he absorbs details of how things work and grow – and also how they fail and die. Yet even when he describes the prolonged funeral cortège of 'The Stiff', the accent falls on life, with the mourners imaginatively reconstructing the mental life and sense impressions of a young man they never knew.

With the exception of 'The Stiff' and 'A Dispatch from Ghana', all of these pieces will be new to the English-language reader. In Poland, they are regarded as a central part of Kapuściński's work

and a model for the excellent domestic reporting that has flourished since the collapse of communism. They embody his arrival at the height of his powers. He surely felt that he, too, had reached the point where he had to make something of himself. He would soon set off on the prolonged foreign assignments that sealed his international reputation. Seldom again would he allow himself to write with such freedom and verve.

The Dune

Trofim discovered the Dune.

In '59, somebody important in the county asked him: 'Do you know how to be a watchman?'

Trofim thought about it. Why not?

To which the important person said: 'He can go.' They took him there on a wagon. He stood in the farmyard and looked around.

A wasted world surrounded him.

Weeds, rust-eaten machinery, doors hanging off their hinges. Heaven is beautiful, but the earth is abject, he might have thought, because that's the philosophy he has. He walked the path down to the lake and found the Dune. The wind struck the sand and the sand trembled and sang. Trofim listened to this music.

When music penetrates loneliness, it takes away a person's pain.

'I lit a cigarette and thought: I'll probably stay here.' There was a horse, and he fed that horse. 'I tidied up a little, but I can't do much, because I have a stiff arm.'

Later, they sent Rysiek. 'Where are you from?' Trofim asked. Rysiek told me: 'From an accident. A hole in my forehead, eight broken bones. I'll remember something in a minute, Mr Reporter, but I can't think of what, because my brain is shaky. I remember that I had a wife and I had a motorcycle. Drink, I drank heavily. When I couldn't stay on my feet, my wife would drag me to the motorcycle and say, OK, go. I always sobered up while riding. But that last time – I don't know anything. I lay unconscious in the hospital for two months.'

Thirty-five years of his life got away from him. If Rysiek happens to die at around sixty, he will pass on tormented by the

thought that he is leaving the world as a 25-year-old boy, for whom things are only starting to open up. Things like that are especially hard, and Trofim the Mystic feels that it will be a just punishment for Rysiek's sinful life, because when God opens an account of damnation for somebody, he fills it out pedantically right down to the last line. The accident left Rysiek with bifurcated vision. He sees everything double. Two faces, two women, two bowls of borscht. It's beautiful that Rysiek sees two moons, like Mickiewicz on Lake Świteź. He has a knack for watches. People from all around bring him antiques, and Rysiek fixes them in the evenings. The piece of junk lies before him inert and unmoving. Finally, it starts ticking. Rysiek leans over and listens to how the stream of time flows through the movement like an invisible river lapping against underground rocks.

'Maybe you were a watchmaker,' Trofim speculates.

'Maybe,' Rysiek says hesitantly, because everything is so vague.

The third one at the Dune was Sienkiewicz. The Dune stands at the end of the world and at the police station they thought that the old man wouldn't get away from there. Sienkiewicz was over seventy, and his chosen line of work was begging. The covetous soul of a Rockefeller had settled into the old-timer, the acquisitive soul of a capital-grubber. And he's a sly one! The old man spurns church-porch poor-mouthing and walks from village to village, saying that he was burned out of his home. The spectre of conflagration hits home to the human imagination, and so Sienkiewicz has amassed a pretty pile of pennies. He always directs his steps so that his peregrination concludes in the provincial capital. There, he allows himself to be apprehended by the police, and the police carry him in their car to the Dune. In this way, the old codger reduces his travel expenses, and Edek the Party Man deposits all the profits into Sienkiewicz's bank book. I asked Sienkiewicz to show me his bank book. He had the sum of 9,365.15 zloty there.

'So greedy,' says Trofim. 'He still wants a shot at life.'

Life pinned them to the land. The world wasted away, and this-tles were running wild outside the window. On the Dune, the sand was singing. One sister of the Dune is the Sahara, and another

sister is the Gobi. There is no one who would ever walk from the Sahara to Trofim's Dune. This testifies to the size of the world. Somewhere on earth fields of tulips are found, and love is given among people. Trofim has not known love, and neither has grandfather Sienkiewicz. Perhaps Rysiek has known it, but behind himself he sees only darkness. In the darkness stands a woman, but that's not the same.

None of them know what they would see if they found themselves far away from the Dune. Trofim has been in Mława, and Sienkiewicz in Olsztyn and Białystok. Rysiek travelled the farthest, but you don't come back from that world with any memories. This is Trofim, this is Sienkiewicz and this is Rysiek. The world is racing ahead, breaking records and firing rockets at the stars. But take a look at the Dune. Watch how a horse dies and how the doors fall off their hinges. Maybe someone will come along who thinks about all of this. Maybe that person will know how to put his mind to work, and then his hands.

In the springtime, Rysiek was building a bonfire. Two men came up to him. One was Edek the Party Man, and the other Lipko the Coachman. Now they were five, and five they remained.

'Bastards,' Edek cursed as he hammered up the holes in the roof. 'Bastards,' Lipko cursed, as he set up the trough. The tractor ploughed the field and Rysiek repaired the machinery. The world turned to face the day and face the night, but it all ran together for them as they laboured. There's history that you read in books, and history that you carry in your bones. And so the history of that farm settled in their bones. It was a simple one. A little State Collective Farm dumped in the woods outside Ełk. Forty-six hectares. Run into the ground for five years by drunken slobs. They finally locked the gang up. But nobody new wanted to go to the Dune. And so the county rounded up people for whom it didn't matter. Who had drawn a lousy hand of cards in life. Who had been washed out.

And Lipko was there. 'Hey, hey, Mr Reporter, I know livestock. I looked after the horses in the biggest droshky stable in Warsaw, at

Wetzel's. In Warsaw before the first war. Our steeds pulled famous people. Actresses, Mr Reporter.' Now Lipko can only laugh at all that. If he has a need for anything, it's to drain a glass in the morning. To save his soul, he says. Because since the time of the war, Lipko's been swineherding and, as he states, he reeks of it. His clothing reeks of it, and his body, but not what's in the glass. It's worse that his soul also reeks of it, which makes that glass necessary, because it also has a metaphysical function. Lipko loves pigs. It seems like he's joking. But why would he? Maybe it's not so funny that a man who went through life and met a couple of thousand people would at last give his heart to the pigs.

The old man addresses Edek by his name, but the others have to call him Mr Director. The droshky driver is proud of his boss. He'll go far, he marvels, and purses his lips to give a little whistle that indicates a particularly lofty rung in the hierarchy. Edek's a golden boy. Born in '31. Headstrong, a self-starter, and a bit of a showoff. He likes to shine. That's even the way he renders assessments: Here we had a chance to shine, and there we didn't manage to shine. Edek took those four desperadoes by the scruff of the neck, sowed the seed, and he's waiting for the crop. He runs around a lot, walks the fields, does the paperwork. 'The sparks! The sparks are flying,' says Lipko in awe. Edek has principles. He castigates Sienkiewicz for capitalism, Rysiek for opportunistic lethargy and Trofim for religiosity.

'Leave Trofim alone,' says Rysiek. 'He's sick.' And it's the truth, because Trofim has epilepsy. Right after the war, a soldier was billeted in his one-room cottage. At daybreak a bandit appeared. They aimed the barrels of their automatics at each other and between them, in the crossfire, stood little Trofim. One gun barrel more than I could stand, he explains. And so he has attacks. He's gloomy, he's humble, and he stands at the side of the road, stands there for hours, walks away, walks back, and then sits down and weeps. If you give him a cigarette, he'll smoke it – but then he runs off to the shop and buys a whole pack. I didn't want to take it. 'Take it,' he says, 'don't put up a fight, because I'll start frothing at the mouth.' So I took it in fear of an attack. Dostoevsky sought out types

like him. 'Have you ever read Dostoevsky, Trofim?' I asked him once.

He had never read him, because books make his head spin. Trofim is twenty-six years old, and when I measure that age against the aspect of him, I feel a throbbing in my temples.

He keeps going out onto the Dune.

The wind strikes the sand, and the sand trembles and sings.

He listens to that music, and the music takes away his pain.

The ears of rye grow heavy and the potatoes ripen, free of potato bugs. Time is on their side, and Edek is calculating the crop. And then suddenly there's that accident with Mongol. Trofim drove Mongol to Ełk to pick up the digging machine. The digging machine was at the warehouse. The shakes came over Trofim there, and he lay on the ground for three hours without feeling anything. Mongol was a punctual horse with a mind of his own. He would always consent to wait two hours. After that, he set out on his own and trotted towards the Dune. That's when it happened. In the evening darkness, along the road through the woods, went Mongol in harness. Around a curve came a truck, and the headlights blinded Mongol. We can assume that he died a double death, which happens to people but is exceptionally rare among animals. First, the light killed him. He was struck by the light, so that he couldn't defend his life. When the option of life was ruled out, the option of death remained. Stunned and inert, he accepted it. It was not that life culminated in death, but that death preceded death.

The Dune was held liable. The horse needed replacing, but they couldn't afford it. This happened at harvest time, and the farm was facing a loss. Edek came up with the idea of borrowing from Sienkiewicz. They pressured the old codger, but the old codger replied: No.

So they convened a court.

They put Sienkiewicz on trial that night.

He lay on his bed with his face to the wall, with his sheepskin coat covering his head. At the table sat the pale Trofim, Lipko the Droshky Driver, Edek the Party Man and Rysiek the Bifurcated, who was working on a watch.

'You won't get out of here alive,' said Lipko.

Trofim tried to smooth things over.

'Man's name is weakness,' he said, 'as shown taking Judas for an example.'

'He's not weak,' Edek objected. 'He's a hardened kulak.'

Rysiek didn't say anything. He leaned over listening to the watch. The watch had fallen silent and time had stopped in its movement.

'Comrade, is this a man?' Edek asked me. I made a face that was neither here nor there, because I never know how to respond to questions like that.

'Sienkiewicz,' I asked, 'did your mother breastfeed you?'

'They say it was by breast,' he answered.

'And what did she feed you after that?' I asked.

'After that, potato peels.'

'Of what your mother said to you, do you remember anything?'

He stirred, and the sheepskin smell carried around the room.

'I remember.'

'What do you remember?'

'I said, "Why are you giving me potato peels? I'm not a piglet. I'm a human being." And my mother said, "When you're as rich as Pan Kozanecki, then you'll be a human being."'

The lamp trembled with a yellow flame and the shadows moved over the walls. In Rysiek's watch, the stream of time began to burble.

I thought that the dirty brat in pants held up by a string took a lot on board back then.

He took on board at least two things: first, there's a difference between a human being and an animal.

Second, wealth is what makes the difference.

You might ask: What kind of wealth? You can give the example of the impoverished Cézanne, who was a great man. You can give the example of Balzac drowning in debt. You can point to Marx. But Sienkiewicz never got as far as those distinctions, and he may have been incapable of getting there. The peasant hut might not have allowed it, and later the years of servitude, and later still the

vagabond panhandling. After the war, they took him into care. They washed him and gave him something to eat. They gave him a bed and a roof. He might have thought: They've arranged for my elementary affairs. Maybe now I can give it a try.

A person wants to be a human being once in his life. And he waits seventy years for it. After that, he reckons it up: I have 9,365 zloty and 15 grosz. Am I a human being now? He asks people that question. And he counts on somebody giving him an answer.

'Leave him alone,' I said. 'I'll finagle the money out of the county administration for you.'

A week later, Lipko brought the new horse home. Lipko said it wasn't the same, but he buffed up the stallion and the horse's short coat glistened. It would also be called Mongol.

Mongol II was harnessed to the mower. Lipko shouted '*Odsie!*' and '*Ksobie!*' like a carter at a coalyard. The field of rye stretched to the Dune.

On the Dune sat Trofim.

The wind struck the sand, the sand trembled and sang.

But now the grain sang, and the mower sang too. The world brightened like on the first day of creation. They had a late harvest; it was August. The summer of '61. As if nothing was going on. Poland was at peace. Europe was at peace. Five people had saved a scrap of land. I have seen how the farmers in Japan defended their fields against the sea. How in Africa they rescued a plantation from the jungle. The earth is vast and no one has yet walked from the Sahara to Trofim's Dune. Everybody knows what the world is like: anything can happen. And here is what happened on the Dune: five people, saving the land, saved themselves. What could they have wanted before that? To try one more time. To have a chance. And they were given that chance. 'It's good,' says Rysiek, 'that they gave it to us. And that it worked out.'

Far Away

The old man was like a fir tree. City guys would arrive from the city. 'He-he,' the one city guy would call to the other city guy. 'His hair looks like kindling. He walks and glows.' But in this place, nobody used to laugh at grey hair. This was a land of old people. A pack of children would run through the village. Somebody would grab one of the children and look him over: crumbling teeth, dull eyes, a wrinkled neck. Old. The child would dash off and trip over something, tumbling into the dust. Rickets. There were no young people here. Many of them were eighteen years old, or a little younger or older, but that's by no means to say that, when they were eighteen, they were young. By no means to say that at all.

They were all old. From old age, there was no escape. And there was no escape from this land for anyone. Encircled by the border. Fields, meadows, the swamp, the forest: the border. On the other side of the border, life must have been better. That's what people would always think. Then they'd go there and come back. They'd ask the one who came back: So, what's it like? That person would say nothing, waving the question aside. The next day, he'd go out into the fields. He'd take up a handful of soil and sniff it. City people don't know that you can sniff the soil. And it had a smell. 'Soir de Paris'. The soil here had two smells: sandy and swampy. Wretched fields, scraggly furrows. If you changed the land, you could change your life. But how? No one knew. A person who doesn't know how to change the land is a poor person. There are perhaps a billion people living in the world today who don't know how. And no one is able to tell them.

Beyond the village stood a marshy little pond. When it started

getting cold, that old man would walk to the pond. That old man who was like a fir tree. They wore linen shirts down to the knees there, and linen pants down to their ankles. Buttons were unknown, and therefore the shirt had to be long because otherwise you'd see too much of a person at a time. The old man pulled off the shirt and pants. Now he could do it: he washed himself. Maybe he didn't have a big bath, just a splash. I remember well how that kind of splashing was done. It was an interesting sight, and children like sights to be interesting. Next he'd take some pine tar and rub his skin with that tar. A double dose would go into each fold of his skin. Fleas don't like pine tar, and lice get stuck in it. That's the way it was done. He'd pull his shirt back on, and over the shirt a sheepskin coat. The coat needed to be belted somehow, and so he'd stretch wire around it. Wired up like that, he'd return to the village and climb up on the stove. Autumn and winter he'd drowse atop that stove. In the spring, he'd go to the marsh. He'd untwist the wire and splash himself again.

Here's that pond. But the old man's not there. Three kids are paddling around in the murky water, snorting and frolicking. I notice that there's a fourth one, too. That fourth one is not swimming. He can't go in the water – he's got a watch on his wrist. He can't take it off, because that would be a loss of face. Everyone has the right to look at that pond and that kid on the shore. Everyone should think at this point: Look, a boy from Cisówka with a gleaming watch!

The village is over there to the right, through that thicket. My mother used to hurry to the thicket to get brushwood. The brushwood went into the stove. The sheet-metal plate heated up until it was just right for stovetop cakes. We didn't know bread. Mother would mix flour with water, and onto the stovetop. This is called flatbread. Sometimes there was butter, but I don't recall knives. They had sickles in the village, they even had scythes, but I know that when it came to spreading butter on flatbread, you took a fingerful and smeared it on. I also remember how the butter melted on the hot flatbread. It gave off such an aroma that our bellies howled like a hundred dogs. Father once bought half a loaf of bread.

From far off we could see father, and how he was carrying that bread. My sister and I stood in the window and when I saw the bread, I started crying. Back then, that was the one time in my life when I knew what happiness was.

Now, I ask a girl: 'What do you dream about?'

'Dream about? About buying myself Italian high heels for 1,400 zloty, and having a big room in which there would be an enormous plush carpet.'

'But don't you want to eat?'

'Eat? Why do you ask stupid questions?'

But it's not a stupid question. A question like that can blow up the world. If many people ask it at the same moment, then there's a revolution. But how can I explain that to this girl? In general, you shouldn't explain anything to girls, because their heads ache afterwards.

The village is over that way, where the wires run. Electrical sparks sing in the wires. A bird alights on the wire and it doesn't kill the bird. A person touches it – he falls dead. There's something to this. Each has current according to his needs. To one for the chaff-cutter, to another for light, to still another to get the sewing machine going. It might even be that all of them are running in a single home. A kind of Canada. They turned on the current three years ago. Electrical communism began in the year '58. Everybody worked the light switches to excess. The ones from the city laugh at this. But a peasant doesn't laugh. A peasant takes flipping the switch seriously. Light – darkness, light – darkness. Now he's got what he wants – heaven and hell in a single switch.

Soot marks remained on the walls in the old rooms. The stains have to be painted over. I walk into a room and cross myself – abstract art gone mad. One wall in pastel cream, another in orange, another in blue, and the ceiling in blue. A radio on the shelf, a lampshade hanging from the ceiling, and pride of place for the sewing machine. The children in their beds on white pillows. They all go to school. The oldest of them will graduate this year and then continue his education, because he's clever. He writes clever things in his notebooks. Like what? His mother doesn't know. His mother

does not know how to write or how to read. Who could teach her? Educated people hardly ever used to come here. When someone's educated, they wear glasses. Such individuals would occasionally be seen in the vicinity. They'd come along taking notes on observances, customs, and the ditties at weddings. This was a paradise for them. This benighted region was a paradise for ethnographers. This mildewed Białystok swampland, hidden in the shadow of the Białowieża Wilderness. Lost somewhere in the fork of the Narwa and the Świsłocz, Cisówka could have been one such paradise. In his lectures at the university, our professor used to say: 'If before the war you wanted to find an authentic Slavic rural collective, characteristic of the period of primordial communities in our part of Europe, you had to go – oh – here!' On the map, he drew a circle with his finger in the region of Wołkowysk, Zabłudów, Siemiatycz – and Cisówka, too.

'The populace here does not know the automobile. Arranged for the purpose of observing the reaction of the populace, the passage of an automobile, the roar of the engine and the blowing of the horn evoked panic among the people. The village emptied out as the car passed through.' The ethnographer stood off to the side, the car emerged from the woods stirring up great clouds of dust, and people hid in their attics. The ethnographer wrote it all down. Where did I read that? I sit down on a bench. Perhaps I can remember. Then I hear that roar and the horn blowing. A farmer is riding a WFM in the field. A rake and a pitchfork are strapped to the motorcycle. A motor drones somewhere on the horizon, at the edge of the woods. Sunshine falls on the forest. People are riding back from the fields. Milk-white horses, wagons on balloon tyres.

Will they have anything to carry this year? For sure, there are prospects for a crop like nothing anyone in the village remembers. Neither Wąsaty nor Szczerbaty. Even Łuksza Mikołaj says he can't remember the like. Nine sons Łuksza has, and a daughter too. He's a real peasant, a peasant by anatomy and by social class. Łuksza walks around with his eyes open and he sees what's happening in the village. 'Before, when the shopkeeper brought in a sack of sugar in the spring, he still hadn't sold it by winter. Fifty or a hundred

grams at a time. Now they bring the sugar by the sack and still run short. Before the war they gave me a radio to sell. But a radio before the war cost seven cows. Nobody bought it. Today for one cow I have a beautiful radio, the model called Capital City. There's a radio in every cottage.'

Łuksza has a calling as a philosopher and disputant. I listen to him arguing with the village headman. The land is bad here, he says, and socialism won't take root in a hurry. You can't drive a tractor here. You can, the headman says, what do you mean you can't? You can. But Łuksza's really concerned about DDT, not about that tractor. There are potato beetles. The potato beetle is a political bug. When you give it DDT, it shrivels up and doesn't move. There isn't enough DDT and the peasants are fighting over it. There's a new dispute. Not all DDT is equal. Some has more methoxychlor, some has more lindane, and some has more HCN. These names mean nothing to me. I simply listen to them being enumerated.

In the midst of all this philosophy, night fell. Janiel returned from work at night. Michał Janiel, railway worker and farmer. Two acres of sour land. Four little kids. Janiel works along the tracks. With a pickaxe, he crushes down the rocks so that the ties are tightly seated, because the railway must run on even rails. With this specialization, Janiel is sent to work in Warsaw. Here's why: because labourers in Warsaw don't want to work for that money. So the directorate transports Janiel and his ilk 200 kilometres or more. Janiel doesn't resist. How much does he earn? Eight hundred and sixty-seven zloty, he replies. He says it distinctly, so that it's clear that there's eight hundred, and then on top of that sixty, and then seven to top it off. Even if he broke it down to every grosz to make his pay look better, those are still meagre wages. So Janiel calculates and calculates. When there's not much money, there's always a lot of calculating. Thoughts of zloty fill Janiel's head. Money for this, money for that. There's no talking to Janiel about any bigger matters. Janiel doesn't know that the world's absurd. Hegel would have referred to him as detritus. Hegel himself was a thinking idealist. His philosophy stood on its head. But Marx would understand Janiel. Marx calculated a lot and he commanded workers to

learn mathematics. Janiel, Łuksza, village headman Lasota, Wąsaty, and Szczerbaty all calculate. There's a lot of calculating, figuring and planning going on in the village. We have this grassland here, and if we could release this water to the Narva, there would be pasture for a thousand cows. We could feed the whole country.

The peasant says: the village. But he also says: the country. Cisówka dug itself out of a swamp, out of a feral sinkhole. To a paved road, it was twenty-five kilometres. To the railway, twenty kilometres. It was, but not now. There was an old track here, with a dead end in one direction but connecting with Hajnówka in the other. That track was never in use. Peasants walked along the track – and the police fined them. That was a stab in the back for the peasants. On foot, and they still had to pay. They started complaining to the authorities and a delegation went to the Ministry of Transport. This is what the ministry ruled: We'll give you the railway if you build the station. The peasants harnessed their horses, delivered the earth, and there was the platform. It opened in December 1959. There are few train stops like this. Lovely, thick woods begin right next to the track. At the top of the embankment, in the middle of the platform, a hole was dug for a pole and an oil lamp mounted on the pole.

People come along, sit down in the woods, and wait for the train. The women converse and the men light up cigarettes. Someone looks around and the silver arrow is approaching. People leaving Cisówka ride the best of trains, an up-to-date diesel Lux-Torpedo. The Torpedo stops, the people gather in the woods and get on. The train moves away. I also rode the Torpedo. Spacious. Comfortable. Two women sit opposite me, chattering away. One of them is carrying eight empty baskets. She had brought fruit in those baskets, to sell. 'You're wearing yourself out. Isn't it ruining your health?' says the other one.

'You do what you have to do. My husband earns twelve hundred and I have three sons studying in Warsaw. One at the Polytechnic, one in law school, and one in economics. You know how it is. As long as my health holds out I'll do anything for those children. Yes, yes, of course. Oh, look.'

I look, too. The Torpedo flies along, the women talk, a hen pokes its head out of a basket and looks flirtatiously around. What a forest, splendid! A green shadow, a damp aroma. Where is he, the tall, proud tree? He has branched out. The train rolls thump-thump, the train is going a long way, the sun is shining in a cha-cha rhythm.

It's beautiful.

A Survivor on a Raft

'What a getaway!' the lecturer cries. 'A fairy tale, not a getaway.'

'And you'll see Zeus, that strange deity,' adds the second lecturer.

A reportage about a deity! That's what got me.

When they have a grosz, they rush off to that getaway every Saturday. They started their pilgrimages as early as May. A little too chilly, but so what? Chilly and therefore empty! They finish their classes at the university at noon, grab their briefcases, onto the tram, to the station, and they're on the train. The main line to Działdowo and change at Brodnica. In places, the road runs alongside the train tracks. Cars, motorcycles and scooters race along the road. The two of them look on awkwardly. They teach the history of literature, an honest trade but not one that will make you rich.

The train carriage sways and they read their books.

From Tama Brodzka station, on foot through the woods, they reach Stanica Wodna. The nest of houses spread across the flattened slope of the hill is called Bachotek. The lecturers straighten their shoulders, do some deep knee bends, and finally become motionless. 'Is it ringing?' one of them asks.

They listen. 'It's ringing!' the other one whispers.

'What's ringing?' I ask (I can tell that I'm making a fool of myself).

They're taken aback. 'The silence, my good man. The silence is ringing!'

They set about eating. Dinner is available at the inn. They disdain this. They solemnly set up the cooker and prepare instant oxtail soup. The water boils over, putting out the flame and

scalding their hands. They eat by turn with a single spoon. They're hungry but they convince themselves that they've never been so sated.

They're already moving across the lake in a kayak. I can barely keep up. They spot a swan. An argument breaks out over whether swans fly high or not. Of course they fly! You townie, you're wrong! They argue and seek proofs from literature. Who could have written about swans?

Żeromski, Konopnicka? Give me a break with Konopnicka – that's not great poetry! The startled birds take off from the water and alight in the reeds. They reach a compromise: So, we'll check in the encyclopedia.

A heron is wading in the distance. They splash their oars, hurrying in that direction. Soon, they'll see it close up. But the bird hears the noise, takes to the air and flies away. Disappointed, they exchange accusations: We paddled too slowly. In self-justification, they show each other the palms of their hands. They're covered in blisters.

They rest oars. 'We'll drift,' one of them says.

'How? There's no current,' the other protests.

The kayak moves a few metres. They look at their watches, calculating the speed at which the current is carrying them.

Far off, outlined against the background of the woods, a figure is advancing along the shore.

'It's him!' shouts one lecturer.

They strain to see ('Educated, but they have good eyes,' the Survivor will later say).

'No, I don't think it's him,' his colleague says doubtfully.

'What do you mean? Aside from him there's nobody else here,' the first one maintains.

'But remember how he put his back into it, and this one's not straining at all, he's strolling,' his opponent argues.

The discussion drags on and the uncertainty torments them. They'll paddle closer and then everything will become clear.

As they approach, the silhouette grows and takes on a distinct shape. The spirit of triumph wells up in my friends. Of course it's

him. Pushing his pole into the bottom, the solitary raftsman guides his craft along the lake.

'Good afternoon, Mister Jagielski!' they say.

The raftsman looks at us and his eyes twinkle with amusement.

'Well, good afternoon,' he says.

'Can we get on? Won't it be too heavy?'

'What do you mean, heavy? What does it weigh?'

It (that is, the three of us) can't weigh more than 200 kilograms. We therefore have no scruples about tiptoeing along the tree trunks in the direction of Jagielski. The lecturers take the raftsman's hand. ('Incredible,' one of them told me later. 'I thought that it would be a heavy hand, lumpy and hard as the sole of a shoe. But he has soft, delicate skin that I'd say is like moleskin!')

Józef Jagielski looks at us and we at him. He's a smallish guy, with narrow bones and the muscles of a flea. A thin face with a sparse, faint beard, hidden in the shadow of a wide hat brim. He looks like he's in his early thirties but he's twenty-five. He's already been in the army but hasn't yet taken a wife (Why hurry, gentlemen?). The army is significant in his life, because that was when he rode on a train. He didn't ride far, but still. Now, he doesn't have any occasion.

'Have you ever been in a city?' asks one of the lecturers.

'Sure I have, gentlemen. I've been in Brodnica, I've been in Jabłonów and I've been in Toruń, too.'

'Have you been to the seashore?'

'Well, no. The seashore? That's too far.'

I look around the raft. It's gigantic. A dozen pine trunks, slightly dried out and bound together, make up one segment. The second segment and the ones after that are attached by wire. All told, there are over twenty of them. It's a long raft, stretching more than 200 metres. They put it together in the Iława forests and float it from there to Drwęca. The wood goes to a sawmill. It floats some 120 kilometres, and several raftsmen guide the raft in turn. Jagielski is one of them. He has his own stage. He tows the load through the lake and the job is done. Several people therefore make money

off a single raft. The overall total of these earnings is the summit of Jagielski's desires.

A lecturer sounds him out: 'What do you dream of?'

'Oh, nothing in particular,' the raftsman says evasively.

'Come on, don't be shy,' the lecturer insists.

'To have all the cash from these rafts for everybody for a whole month.'

'How much is that?'

'I fear to say, gentlemen.'

'Well, don't be afraid.'

Jagielski straightens up and takes off his cap. 'It would be some three thousand. Or maybe even four.'

He sets furiously to work to avoid getting carried away with this idealism. He makes 800 to 900 zloty a month. This is the pay rate: for moving a cubic metre of wood over a distance of one kilometre, he gets twenty-two grosz. One Giewont cigarette. Supposedly a worker, he labours like a peasant in the field. He lives in the village with his brother, to whom he turns over his wages to cover his food and a corner of the room. He gets up with the chickens, eats some potato soup, fills a bottle with tea, and rides his bicycle to the place where the raft is waiting. He cuts down a young spruce tree, strips it, smooths it, and he has a pole, the tool of his work.

He stands on the raft.

'The rest, gentlemen, is by the grace of God.'

If the wind's against him, he doesn't move a single metre.

A wind from the left pushes the raft against the shore, where it snags in the reeds.

A wind from the right pulls the raft into the middle of the lake, where the water is too deep for him to get a purchase with his pole, and he waits for salvation.

If there's no wind, the whole effort of moving this mass of wood rests on his shoulders.

Backbreaking labour.

Good winds visit him seldom. Usually, the wind is his enemy. How far will he float by evening? If things go well, six kilometres (once, it was eight, he says proudly). He has to be opportunistic, far

enough from the shore not to get hung up, but close enough to touch bottom.

The lecturers are delighted by the fact that Jagielski is also sometimes adrift. They've been adrift for a long time. A crisis of values has occurred in the world, they say. Traditional institutions have been compromised, morality no longer makes sense, and acknowledged truths are questioned. They do not even trust the facts they teach. Weren't texts being falsified centuries ago? People act under the terror of circumstances, like a raft that behaves according to the wind direction. People have been cast adrift. One of the lecturers, balancing precariously on a tree trunk, summons up the testimony of Pascal. (I hunted down the quotation: 'Man does not know in which rank to place himself. He has plainly gone astray, and fallen from his true place without being able to find it again. He seeks it anxiously and unsuccessfully everywhere in impenetrable darkness.') Shadowing Jagielski, they observe the phenomenon of being adrift as it manifests itself not abstractly, but concretely. The raftsman penetrates the water, lowering the pole all the way to the hilt. No bottom. They wait in suspense to see what he will do.

Jagielski lays down the pole.

He sits down and stretches out his legs.

'We have to wait,' he announces.

This statement strikes them as brilliant. 'A philosopher,' one of them says.

'A true philosopher,' the other one affirms. 'He doesn't get hysterical, he doesn't feel despondent, he doesn't flounder around, he doesn't turn bitter. Although every adversity of nature cuts into his earnings, the raftsman remains calm. Wait – and the bottom will come to him. The bottom escapes, and then it's there. There must be ground beneath him!'

Does he like his work? For sure. He was in the sawmill once, but he left. Too many bosses. Here, Jagielski is his own boss. He can work by day or at night, as he chooses. It's good by day and pleasant at night. ('When it's dark, it's so quiet that you feel it somewhere deep inside.') Just so there's no bad weather. Then he struggles and pulls until he blacks out. More than once he collapsed onto the tree

trunks with the water lapping over him, and it didn't matter. 'It doesn't make any difference at that point,' he recalls. Last New Year's Eve he leaned so hard on the pole that he lost his balance and fell into the water. He dragged himself out of the freezing abyss and, dripping wet, walked home in the frosty night – ten kilometres. ('That's how I greeted the new year, in my waterlogged underwear.')

'So you missed the party!' the lecturers conclude. Fun, entertainment. They ask whether the raftsman has any contact with culture. No. He's never been to the theatre. He was at the movies a year ago. He's never seen television, he doesn't listen to the radio, he's never happened to read a book, and he doesn't look at newspapers.

He doesn't talk to people much, either.

And so the great wide world has no way of reaching Jagielski. No news. Neither hope nor anxiety. Neither sensations nor boredom. Nothing, never. The raftsman does not know about earthquakes, about palace revolts, about the fate of the U-2, about the fiasco of the Paris Conference, about the Rome Olympics. Hearing the information from the lecturers does not even pique his curiosity.

'It might all be so, gentlemen.'

He doesn't inquire about details, he doesn't ask for more. He starts working the pole, trying to catch the bottom.

The lecturers are enchanted: 'You see, he didn't let himself be drawn in! For him, our world is a shoal that he steers clear of. He steers clear of it subconsciously, but effectively. Perhaps instinct whispers to him that if he runs aground on that sandbar, he might never get clear of it. It's terrible how people keep running aground on one shoal or another. Home, job, habits. A point of sterility and numbness. And there are no winds that could push them back out into the current. Or such a wind comes up, and they lie down prone – they're afraid of getting blown away. But see: Jagielski waits for the wind and the current. He lives with them, and lives by them.'

'He didn't let himself be drawn in!' they repeat enviously. 'He's

self-sufficient.' As these enthusiasts see it, being Olympian need not necessarily be showy. These times cannot bear empty pretences. They are exaggerating. They see the root of divinity (that is, something inaccessible to humans) in independence. This raftsman is independent. So they call him Zeus. The fact that he wears a hessian shirt and has holes in his rubber boots – so what? They bow low to him, stroke his hand, and repeat his remarks like aphorisms.

'Mister Jagielski, will there be good weather?' they ask.

The raftsman looks around at the sky (he reads the sky, they say) and, pushing hard on his pole until it bends like a drawn bow, pronounces: 'There are clouds, but they might go away.'

'An optimist!' the lecturers marvel.

A Farmer at Grunwald Field

On the field between the Germans and the Royal Army, in
the direction of Tannenberg, there rose several age-old oaks
up which local peasants climbed to watch the contention of
those armies so enormous that the world had not seen the
like from time immemorial.

Henryk Sienkiewicz, *The Teutonic Knights*

Piątek deployed to Grunwald neither mounted nor afoot, but on a
cart. That expedition had a singular look, for Piątek did not ride
alone or with any entourage, but rather carried athwart the
packed-down straw his wife and four kids, besides which a sack of
down and the implements most needful to him. The horse daw-
dled, and so he lashed it with his whip until the panicked flies
dropped off its frothing haunches. As he did so, he swore that God
would forgive him.

He did not find any battle there.

There were still, of course, fires here and there throughout the
vicinity, there were blackened ruins and the stench from the burn-
ing, and the roads were still full of all sorts of military junk, but the
clash of arms had sounded and fallen silent already, and in its place
the larks trilled gracefully, and the water in the ponds rippled quite
placidly.

It struck him as beautiful. He stopped the horse, climbed down
from his perch, took up a handful of earth, weighed it for a long
moment, and sniffed at it.

'I liked the soil right off,' says Piątek when we reminisce

about the final year of that dire war and the peace that followed suddenly.

'The soil didn't let me down. Look here how good this rye is. How heavy the heads are.'

The field of rye stretches for a kilometre, spilling out broadly almost to the grave mound of Ulrich von Jungingen. A horse-blanket is spread out at the edge of the rye, and Piątek and the reporter are sitting on the horse-blanket. In the winter Piątek was carrying wood for the barn when a tree trunk crushed the bones in his hip and thigh. The bones grew back together but Piątek can't walk. He doesn't have the strength to control his leg. So he whittled crutches out of oak and he leans on them. If the weather is good, he immediately exposes his flank to the sun in the hope that the warm rays will draw the debility out of his behind. The sky has cleared up just at this moment and Piątek is warming his body, angry to be holidaying when there's so much work in the fields.

Since he became physically infirm like this, the farm has been in decline, and he was once first among the farmers here, the authentic master of the fields of Grunwald. He came here right after the war and got a house and land. He came here from the poverty of Mława county, reckoning that he'd be better off. There, in Niedziałki outside of Mława, he hadn't made anything of himself. Before the war, he managed to set aside wood and bricks for a cottage, but he never erected it, because the Germans took away his building material. Piątek fought his war against the occupier not with weapons, but economically, with stone. They ordered him to deliver stone, thirty kilometres, a whole wagon full. Piątek loaded on sacks of straw, and a little stone on top, and that's how he drove. It was no strain on the horse, and in his own way he had his revenge on the Germans.

In Grunwald, he quickly rose to the top. He knew how to run a farm, he liked working, and he said the right things at meetings. He became the village headman. He fulfilled his duties. Over time the children came along, and so he resigned from office and concentrated only on his home. He bought some more cows and expanded the outbuildings.

I listen to his account. I look around: a flat plain, clumps of trees, potato fields.

'There was a great battle here,' I begin.

'Not really,' he replies. 'The front passed right through.'

I catch on that we're talking about different wars. I draw him into the whirl of that feudal one, but he clings to the image of the last one, the World War. I've read Sienkiewicz, seen Matejko, studied Kuczyński. The Teutonic Knights' army came up here (I point out the spot), Jagiełło here (I point), and the Lithuanian wing stood there (I point). Piątek follows my hand with his eyes, looks around and groans because it hurts where his bones are growing together. An awesome multitude of knighthood, I say. A world-shaking event! I look to see whether Piątek is catching my enthusiasm. But no. The peasant's eyes are not afire. He looks rather worried. Timidly and stuttering, he asks: 'They won't trample my grain, will they?'

'What do you mean?'

'You know. Whole throngs of them are supposed to gather here from all over Poland.'

We are sitting on the slope of the embankment. A road runs along the top of the embankment. Columns of trucks are rolling past. Laughter, singing, a multitude of voices. The hubbub fills the air with a carefree din. There is a crossfire of calls and an intermingling of shouts. Vehicles are turning onto a side road in the woods. Tents are set up in the meadow and smoke rises from field kitchens. A crowd spills out of the trucks and divides into groups – for the concert, for the lecture, for the meeting. Piątek can't see this, because he can't drag himself over there on his crutches, but he knows that there's a youth rally in Grunwald, that enormous contingents have come here from all over the country. He even likes the fact that his area has taken on such importance. That it means so much now. But he's worried that the thousands of feet will crush his field, which has been growing so promisingly.

'I thought about fencing off the field, but it's too much for me.'

'Maybe it's not necessary.'

'They say there are going to be parachutists. With parachutists, fences won't help.'

We both ponder what to do. Piątek reassures me: 'This field is mine, sir, I have the papers for it. I have the land grant and the tax receipts. The taxes are paid. Deliveries on time. Everything's in order.'

I believe him, I say. 'It's your land.'

He's happy to have me as an ally. Maybe we can think up something together.

'They'll be here a while and they'll go away. But I, sir, am staying.'

Piątek doesn't want to leave Grunwald. Things have improved for him here, he has his hectares and his house. He sends his children to school and he's bought his wife a washing machine. If he were more fanciful he could say:

'The king himself won this scrap of ground for me!'

But Piątek doesn't concern himself with history. The important thing is the land. Wars have rolled across the surface of the land for centuries. The land throbs with hooves, crunches with tank treads, and bends under blows from bombs. But it brings forth, the ears of grain multiply, it yields crops. Wars pass, but the juices always circulate in the soil. The ground accepts warm rain and stinking fertilizer, powdery phosphates and clotting blood. It accepts everything, and always gives back only one thing: grain. In the face of that process of eternal transmutation and fructification that lets Piątek live, it doesn't matter where the battles are fought. When and how. The earth will still yield crops. Piątek will still harvest them.

The Fifth Column on the March

They themselves told how it came about. They said it started with time and music. The time and the music were together. The music lasted in time for an hour, and they knew that their time had come.

They heard a familiar melody. First, they heard distant, shrill tones, and then came lower, harsh notes borne on the breeze and space. They heard singing, the patter of the snare drum, and orders sharply given. They could make out the howl of tanks, the bass drums of cannon, and a cacophony of motorcycles. Groans and shouts rang out. The water rang in the bucket. They were thirsty, and so they had to drink. They banged on the door with a rifle butt, panted, and finally broke out laughing. Laughter and panting are their speech. They hear the commotion. The music rises and fills the room, the porch, and the yard, it rolls along the cobblestone street and penetrates the forest. No one can hear it, except for them. Because they have the *Blutinstinkt*.

'*Blutinstinkt*?' I asked. 'What's *Blut*?'

'Blood. *Blut* is blood,' someone said from off to the side.

So it was like this: two toads were lying motionless. Somebody applied current to their bodies. They jerked, and the blood moved in their calcified veins. That blood went to their brains and filled the grey cells sensitive to music. To that one kind of music that you can hear, experience, and remember if you have the *Blutinstinkt*. And they have it. That's why the one tells the other:

'It's the real thing, Margot.'

'Yes,' Margot replied. 'It's our music and our time has come.'

There are few words in this conversation and you can count

them all on your fingers. But the blood is flowing to their brains and the grey cells are filling with the patter of snare drums. Some grey cells hear it, and others think about it. The head cannot sleep. Two heads keep a vigil that night and their gums gnaw the manna of the rosary. Our Lord, out of your magnanimity, let the dawn come. And so the dawn comes. It is 11 September 1961. It's Monday.

The two women escape from the old people's home in Szczytno.

Nobody sees them.

Augusta is older and Margot is younger. Augusta can't stand up straight and so she leans on Margot so that they both can walk with their heads up. Augusta often gets short of breath, so she stops. She hears the music again, but she's out of breath. Then she stops and Augusta waits for that droplet of energy that gives her the impetus for ten more metres. Or for twenty if it's really good.

Augusta Bruzius, born 1876. 'Mister,' she says, 'look at me. My mind is clear, my insides are fine. My lungs and heart are in great shape. And she's younger, but she has *Rheumatismus*.'

That one, Margot, is her daughter. Augusta gave birth to her in 1903. Margot has an excellent education. For ten years, she worked at the courthouse. 'Did she prosecute Poles?' I ask. 'She didn't prosecute anybody. She was just a stenographer.'

A drop of energy coalesces somewhere in the healthy insides of Augusta, so they keep going. By noon they're at the train station. They buy tickets.

'Two tickets for Taubus,' says Augusta.

'That cashier, she gave us such a look. She had no idea where Taubus is. Margot had to tell her that we want to go to Olecko. And then she looked at how green the coins were. It was *Schimmel*, mould. I'd been saving them ten years for that ticket to Taubus.'

So they had their tickets and they rode to Olecko. The beautiful Mazurian countryside moved outside the train carriage windows in the smoke of rain and fog. There were a lot of people on the train, a lot of people at the stations and on the roads. What could they know about the *Blutinstinkt*? It had nothing to do with them. Only the two women had everything in their blood that they

needed to hear the music. That was why the one said to the other: 'It's the real thing.'

And the other one answered: 'Yes.'

Five words you can count on your fingers. But enough to make sure. In their brain cells, the snare drums patter. The howl of tanks and the whine of engines drill into their brains until it hurts. The water rings in the bucket. They're thirsty, they need something to drink. Two old ladies are on their way to grab some Poles by the throat. Two old ladies on the train to Olecko. They need help, they need protection. Grey-haired, hunched-over ladies on the road. Could one of you gentlemen give us your seat? Close the window? Open's OK. Do you ladies have far to go? 'To Taubus,' says Margot. 'To Olecko,' Augusta explains. Is it a family visit?

They don't say anything. What's the use of saying they're going to get their two houses back? Those houses, Augusta tells us later, were left by her husband, Bruzius, the leading pork-butcher in Taubus. They had ninety *voloks* of land. A hundred Polish farmhands worked there. Her husband was driving a jog cart with two horses once, and he struck a high stone. Her husband fell between those horses and died. Her husband left her the land, the houses, the farmhands, and Margot. The Polish state took away the land and the houses. The farmhands left on their own. Margot remained. She and Augusta wanted to go to Essen at the time of the transport, but Margot came down with that *Rheumatismus*. They were in the hospital in Szczytno for a long time. Then they were in the old people's home. It's noisy all the time in the old people's home. It was noisy that Sunday, too, but then it all faded away and they could hear those sounds.

'It's the real thing,' Augusta said.

'Yes,' Margot retorted. 'It's our music and our time has come.'

They set out into Olecko. From the station, they walked to the town square. Those houses stood on the square. Big townhouses. All at once, something was wrong: the music didn't follow them into town. No patter of snare drums and no bass drums of cannons. Olecko was quiet, drizzly, drowsy. People were living here the way they do all over the world. They were bustling over their minor

affairs, trying to make a little money. Farmers were buying nails, children coming home from school, municipal clerks sipping cold, weak tea. It didn't sound like a song. It wasn't any kind of music at all.

Augusta and Margot knocked on the door. Later they would say that a boy opened the door. He thought they were begging and he said: I don't have any small change. He pointed to the next door. So they went from door to door, two grey-haired women who needed help and protection. At every door, they recited their formula. This is Germany now and you have to leave. You get out of here because my sons are coming. They said it in German and the people didn't understand. Some of the people winked at their neighbours – they're nuts. That's how it often is with people. They don't know how to hear somebody out. They catch ten words but don't wait for the full stop. A sentence broken off in the middle sounds crazy. And so they say: Nuts.

But they weren't nuts. I talked with them for a long time. Augusta was right – her mind was clear. All they did was go to the common room in Szczytno in the evening, where there was a powerful new radio. They spun the dial in the ether. The magical eye blinked nervously. The old ladies caught Adenauer. They pressed their ears to the speaker and the snare drums pattered in their brain cells.

They spent three days in Olecko. The music never came, and they never found those *voloks* or the Polish farmhands. They went to the People's Council to complain. The people there also thought they were nuts. They told them to go back to Szczytno. They refused, they wanted to be close to Olecko. They were given money to buy tickets and they travelled to Nowa Wieś near Ełk. There's an old people's home there just like the one in Szczytno, but it's a hundred kilometres closer to the place where Herr Bruzius, the biggest pork-butcher in Taubus, employed a hundred Polish farmhands.

It was evening, and rain and cold harried the land. They came into the dining room, dragging a trail of water, dusk, humility and fatigue. We sat on a bench with the director.

'*Herr Führer* . . .' Margot began.

'I don't understand that!' shouted the director. 'Speak Polish!'

Margot withdrew into herself. She didn't want to talk. As long as we were there she didn't say a word in Polish. But Augusta spoke: 'We travelled to Olecko because we thought it was already Germany, and then they told us that it was Poland. I wanted to take back my houses so I could welcome my sons there.'

'What sons?' I asked.

Well, she had four sons. One son on the Ukrainian front. A second son on the Syrian front. Those two sons stayed on those fronts. But the other sons are in West Germany. They're there, those sons. They're going to come here to make peace. They're going to come from America. Those sons, here.

The scraggly spiders of her words crept around my brain. I looked at her. She was eighty-five, but if she got it into her mind to dance the *Wienerblut*, she'd kick up the dust on Olecko town square. Margot was less lively. Hunched over, toothless, her lips sagged into her gullet. She had bulging eyes and she had rimless lenses tied in her hair with strings.

'Where are your things?' asked the director.

They had left everything in Szczytno. They didn't have time to take anything, because they were in a hurry to get to Olecko before those two sons, who were supposed to be coming from America, got there. They didn't need anything. They only wanted something to eat and a place to sleep, and they would leave for Olecko the next morning because their time might come tomorrow. And maybe there would be that music to fill the time.

We weren't alone, because in the meantime people had started coming in and were straining to hear. They were elderly people, the residents of this home. They had withered faces, shrunken bodies, and minds afflicted with sclerosis. They spent their days sitting and watching the road where no one ever came. Or they looked at each other, and then they started crying. They were going deaf and blind, losing their senses of taste and smell. But they still remembered one thing or another. The women could still enunciate the names of their sons who had been killed, and the men recalled the addresses of houses that had been blasted away by shells. They

were lonely and helpless here, because that was what the war had done to them. War stalked often over this land where it had been given them to live, have children, labour and die. They all had accounts that they would like to present to those musicians. Each of them had a score to settle with those players who made such splendid music. These old people knew that the two women were not nuts. They knew: two toads had been lying motionless, and someone applied current to their bodies. They jerked, and the blood flowed in their calcified veins. That blood went to their brains, and the patter of snare drums filled their grey cells.

That's what it was, just like that. And that's why the old man standing at the head of the crowd said: 'Chase them out!'

And others repeated after him: 'That's right, chase them out!'

Something had returned, some evil, accursed fragment of the past had returned and brought the blood back to the pale faces of the old people, which had long ago dried up, which had long ago ceased to express anything. But they didn't have the strength to move. They stood crowded together like that, casting their judgement from their toothless jaws, their curses, their numb despair. But perhaps it wasn't a lack of strength, only some kind of solidarity of old age, the instinctive community of a world receding into the dust, blind, dull and deaf, but still aware or at least intuiting that they couldn't expel these old women into the rain and cold, at night.

So they stayed there.

The director said that he would order a car the next day, and they would be taken to Szczytno. They didn't say anything. They ate their fill and went to sleep, and in the wet dawn they ran away, the one leaning on the other, vigorous and well rested, with that patter of the snare drums in their grey cells.

An Advertisement for Toothpaste

The sax wailed piercingly and Marian Jesion shouted: 'Let's go, boys.' On the forest road through the limitless darkness Jesion's grandmother sighed a tremulous whisper: 'Oh God.' Those three voices, raised simultaneously but so clearly out of step, weigh like a stone on the village of Pratki in Ełk county.

The girls from Pratki tell me that it was a lovely dance. The band came all the way from Olsztyn. Two people appeared with the band: a fantastic entertainer and a singer with fashionably teased hair, except that she was a bit too much on the scrawny side. The village hall had been swept and all the windows washed. The special effects came out great: red and blue light, filtered through rustling fronds of crepe paper, filled the hall. On the right wall, as seen from the door, it was more blue, whereas intense red flamed on the left. The girls stood on the blue side and the boys on the red side. They were divided by the multicoloured expanse of the village hall with the bandstand pinned in the middle like a brooch, but of course they could see each other clearly. There are fifteen girls in the village, and there are four boys. The girls saw how those boys stood stiffly in the romantic black of their suits, with plastic ties on elastic bands under their chins, the brilliantined masters of the world in wafts of Derby Eau de Cologne (produced by Lechia in Poznań). The boys looked pensively in the direction of the girls, evaluating the quality of their high heels, nylon dresses and Czech jewellery, as they mulled over all-too-predictable plans to be implemented later.

The girls told me that the saxophonist from Olsztyn, known throughout the province, started off by playing the hit of the

season, titled 'Twenty-Four Thousand Kisses'. That hit is dazzling, and at the same time shocking. On hearing it, Marian Jesion shouted: 'Let's go, boys.'

But no one even moved a muscle.

A tension-filled hush descended.

The four boys glowed amaranthine on the left-hand side of the village hall, and the fifteen girls stood in shades of blue to the right. The cause of that tension-filled hush, into which the saxophonist known throughout the province wailed penetratingly, was obvious. It resulted from arithmetic. 15 to 4 is a good score in team handball, but it represents an atrocious disproportion at such an exceptionally glittering dance party (band from Olsztyn, great special effects).

The hush came from the red side, concentrating on making their choices, and emanated from the blue side, whose hope was as soundless as the silence of the stars. They all knew how many things in the village would depend on what happened in a moment, and so no one had any desire to make an ill-considered move. At last, the four on the left crossed over and enunciated the traditional formula to four of the ones on the blue side:

'Let's waltz, all right?'

The phrase 'all right' is absolutely rhetorical in nature here, added exclusively in order to lend the sentence a fluid cadence like something out of Sienkiewicz. If any of the girls replied: 'No', she would spend the rest of her days in a dubious state of spinsterhood. Therefore, the four from the blue side responded: 'Sure', and the couples moved into the centre. The saxophonist known throughout the province worked the gilded valves of his instrument and Marian Jesion shouted something in a loud voice. The saxophonist and his instrument had to play loudly enough to drown out the trembling whisper of Jesion's grandmother, who stood on the road amid the limitless darkness asking 'Oh Lord, why did he do this to me?'

The four couples performed their first turns. They were precisely calculated according to Euclidian and formalistic principles, like the timeless motions of the planets or the course of Sputniks

around the earth. Those who remained on the blue side looked on with a mix of envy and criticism. Some of them deluded themselves that the soldiers would still show up. The soldiers came from Ełk – always the same ones. They were brought here by skinny, dark-haired Kazik, the corporal in charge of cultural affairs. Kazik had read many books and watched 700 movies. He entered every film in a notebook and totalled them up every quarter. By the end of his service, he might hit 800. Kazik, however, is treacherous, because he tells every girl the same thing. 'What does he say?' I ask.

They laugh, until one of them finally repeats it: 'Girl, I will drink delight from every cell of your body.'

He's from Warsaw, that Kazik, which is why he's such an intellectual. Soldiers are dangerous because they get carried away. They are on a pass that's good until ten o'clock and they want to close the deal in time. They have no regard for contemplation, and they dictate the tempo from the start. In such haste, a girl can forget herself, and after that nothing remains but death.

'What do you mean, death?' I ask.

'Really. What else is left for her? Only killing herself. The ones from Pratki are better, but even they fidget around too much.'

The saxophone croaked out the last bar of the hit and the couples broke off their geometrical evolutions. The four boys standing against the wall went out behind the village hall, where they retrieved a flask hidden under a juniper bush. They drained it. The girls tell me that such is the custom and it's better that way, because it livens them up. Too much isn't good, but a little bit is good. The boys returned to the concrete-floored village hall and by their faces it looked like they had been under some enormous strain. In the hearts of the girls there again arose a hope as soundless as the silence of the stars.

Keeping pace with the latest achievements, the band known throughout the province launched into 'Diana', and the scarlet veins stood out on the skinny neck of the scrawny singer. The next four girls were led from the wall into the centre, where the red blended with the blue and settled into a respectable purple. Again the couples began absorbedly describing circles on the village-hall

concrete to the beat of the song that the scrawny singer was enthusiastically belting out.

After that number, the girls tell me, the boys started pushing and shoving each other. They didn't know what that violent, predatory pushing and shoving was about. The girls think that if there's a fight at a dance, its purpose is not immediate, but rather more distant and somewhat metaphysical. It's necessary to make the dance memorable. A dance sinks into oblivion like a stone in the lake and the waters of time close over it. The dance itself is coarse and boorish, and too many factors prevent it from living on. With a fight there are no inhibitions, and it lives on in full. A fight has everything that sticks in human memory: blood, pain, eyes fixed in hatred, the prickly thrill of death. The village will rehash the details of the fight, and the names of the participants will be repeated many times.

During the quick waltz that followed the fight, the couples adopted a style ordained by the fantastic entertainer. They passed in front of the band with the step that's obligatory during the Sunday promenade. The girls tell me that the promenade takes place every Sunday afternoon in the village. First the boy shows up at the girl's house and asks: 'Want to promenade with me?' The girl must introduce him to her father and the father must converse with the boy. On this occasion the beau opens a flask, because dry conversation is like goose down in a gale. This legalizes the act of promenading. They walk along the road from house number one to the last house in the village, and back. They can't go into the woods, because that's disapproved of. From time to time during the fulfilment of this sterile and tedious procedure, a word is uttered.

'So what do you talk about?' I asked.

One of them replied: 'This and that.'

On this basis I could not deduce whether these conversations are interesting or boring, because I do not possess the Egyptological talent that can derive the stormy history of a dynasty from a single hieroglyph.

In the opinion of the girls, their friends in other villages, where

the balance of the sexes is not so glaringly disproportionate, are better off because they can be choosy. They can be choosy when it comes to boys. When he comes along with his invitation to go globetrotting, the girl first asks him: 'Are you going to move to the city or stay on the farm?' If he intends to stay on the farm, the girl sends him away: 'Go promenade by yourself.'

With a boy like that, there's no hope of getting out of the village, and all the girls want to move to the city.

'Why?' I ask.

'Because in the city there are so many cinemas, and people don't have to do things.'

'But on the other hand it's dangerous in the city,' I say. 'There are lots of accidents.'

'So? We have accidents here too. Not long ago one girl was going to feed the chickens, and she slipped and broke her arm. That's an accident, too.'

The fantastic guy known throughout the province performed his routines. He managed to conjure a flag out of thin air and hung it on a specially prepared pole. The band played the national anthem and the scrawny singer stood at attention on stage. That was the last waltz, the end of the planetary revolutions, and the metaphorical significance of the red and blue was no more. The door of the village hall opened and four snuggling couples walked out into the tunnel of the night. A moment later, the group of stiff, silent, resentful girls followed in their trail. These were the eleven not chosen, abandoned to the predations of loneliness, neglect, and the night – that same night in which Jesion's grandmother, at the end of her strength, managed to whisper on the forest road: 'Oh God, why did he . . .'

And she fainted.

A police van took grandmother to the old people's home in Nowa Wieś, outside Ełk. Now she sits on a bench, rubbing the knee that is swollen from her fall on the road. 'No,' she lisps, 'he didn't throw me out. He only said: "Grandmother is leaving the village."' In itself, the sentence does not sound threatening. It's more like something out of a primer, descriptive and narrative: Grandmother is

leaving the village. Why did he say this to his grandmother? Grandmother thinks it over: 'Because there's not much room in the cottage and my grandson, you see, Marian Jesion, is going to get married. The need has come over him. That's what he told me: "Grandmother, the need has come over me." '

That's why, on that evening when there was a beautiful dance party with very impressive special effects, Jesion's grandmother set out into the vortex of darkness, walking straight ahead into the unknown, into the world. Grandmother entered into the darkness, and her grandson, Marian Jesion, in his romantic black suit, the brilliantined master of the world in clouds of Derby Eau de Cologne (produced by Lechia, Poznań), danced to the dazzling and at the same time shocking hit of the season, 'Twenty-Four Thousand Kisses', piercingly wailed by the saxophonist known throughout the province.

And everything's the way it should be.

Marian Jesion will ease his excruciating need, and his grandmother will have a government roof over her head and a government bowl of bean soup with bacon. What will change is this: because there will be one less mouth to feed in the Jesion household, expenses will be reduced and Marian, with all his needs, will be able to buy himself a plastic tie on an elastic band. This is unquestionably a symbol of modernity, and in Pratki there is a big turning towards modernity. My girls tell me that people are now buying everything: sewing machines, WFM motorcycles, sofas and watches. People are striving after radios, suits, crystal and washing machines. In strict confidence, the girls tell me that some people, in order to keep up with this universal inclination to material prosperity, are simply stealing. And so for instance the cooks at the nearby collective farm steal meat. How clever they are! They sneak ham and pork cheeks out in pails of slop. Then they just rinse the meat at the well and the whole village can buy it. Hence on a fine Sunday the sly cooks can adorn their bell-shaped bosoms in the blue mist of expensive chiffon blouses.

'Do you know that stealing is a sin?' I ask.

My charming girls from Pratki laugh, but it's not a natural laugh,

pearly and dazzling, but rather a grotesque, clownish grimace of a laugh in which their lips stretch from ear to ear but remain clamped tightly shut, and their insides seem to shake autonomously in a hysterical convulsion. They have to laugh that way because they have no teeth, or, more precisely, they have a few teeth, scattered here and there, sparsely, like rotting stakes in a forest clearing.

As badly brought up, as notorious a boor as I am, I ask my girls: 'Why don't you gals brush your teeth?' But why ask about that? Nobody in Pratki brushes their teeth. Pratki girls chew that ham with devastated, bare gums, and the boys, after downing a glass of moonshine, ruminate like old men over a mouthful of pickles. Pratki bachelors buy themselves motorcycles and the girls acquire, for a pretty penny, fashionable organdie slips, which is why nobody can afford a tube of Odonto toothpaste (produced by Lechia, Poznań) for three zloty and five grosz. It immediately occurred to me to launch a campaign to lower the price of toothpaste, and particularly to roll back the retail price by those five grosz, because maybe that's what discourages people from an excessive, budget-straining purchase when they are set on buying themselves a collection of crystal. I counted on lining up a cohort of backers; the whole issue would meet with a favourable response in the Ministry. Steps would be taken and, with a special directive, that five-grosz barrier would be rescinded once and for all.

But later I came to a different understanding. If they don't brush their teeth, and the idea of such a procedure has never even entered their heads, they could hardly be interested in the price of Odonto toothpaste (produced by Lechia, Poznań), amounting to 3.05 zloty, or take into consideration the fact of those five grosz that were over-zealously added to the round sum of three zloty. The hygienic principle under discussion is ignored because not a word has been said to the people of Pratki in this regard, and no one in the village has independently and spontaneously stumbled upon the idea of brushing their teeth.

And that's the whole truth.

Namely, the truth is that Pratki dances to the newest, dazzling hits, races all over the place on WFMs, stocks up on televisions,

purchases electric sewing machines and Master Picasso curtains, while at the same time the idol of Pratki is still an idiot known throughout the province who is a fantastic entertainer, and at the same time Pratki forces a sick old lady out into the unknown, gets into brawls and foams at the mouth with hatred, and doesn't brush its teeth.

Thinking in these terms, I slipped immediately into idealism and started dreaming. I dreamed that, at the cost of playing three dance records, some responsible person on the radio would say a few words about teeth. That you have to put the toothpaste on the toothbrush, and then you have to rub it in with a back-and-forth rotational motion, and afterwards you have to spit it out instead of swallowing it. That there are hopes for a reduction in the price of a single tube to three zloty. I went on to dream that the county instructor sitting in at the next Party meeting, after discussing the critical issues in the ongoing flourishing of our fatherland, would deign to ask, in spite of himself and out of nowhere: 'And how about those teeth, comrades? Are you brushing those teeth or not?'

Because sewing machines and nylon ties have been exported to Pratki, chiffon blouses and convertible sofas, but no one has gone to the trouble of inculcating a few elementary concepts from the domain of elementary culture.

Grandmothers, and teeth.

Apparently two different matters, but not quite entirely.

On the Ground Floor

This weather is like a slice of bread: familiar, an everyday taste, but without it . . . The three of them are walking along the road, and I tag along as the fourth.

'Can I go with you?'

At first they are a little suspicious, but soon they're joking. 'Why not? Except you have to buy your way in.'

The road runs from Bielawa to Nowa Ruda. Along the way is Wolibórz, where there ought to be an inn, sticky-topped tables and a few shots of vodka in a soft-drink bottle, because today is payday and they aren't selling alcohol.

'Fine. I agree.'

That promise is like a contract. Now things are different. Now we're all buddies. They're manual labourers. They last worked in the Bielawa Textile Works and now they're on the road to Nowa Ruda, because the coal mine there is hiring. Such a change is nothing new for them. On the contrary – it's something of a principle to which they remain faithful. The three of them met up two years ago as dockers in Szczecin. They stuck together because they all come from Rzeszów province, and even from Brzozowski county, so they're home-town boys. From that time on they've been roaming. From among the more important cities, they've been in Poznań, Gorzów, Konin, Rybnik and Tarnobrzeg. They've found employment as construction labourers, farmhands, weavers and machinists. Now they'll be coalminers. They've changed occupations so many times because, in fact, they don't know any. They have no qualifications. They never settle down anywhere. They never work anywhere for long. They never find a home port.

They take life as it comes. Right now it's Wolibórz, that inn, that table and that bottle. Mushy herrings on a plate. Sweaty foreheads and jostling – 'Wait, Władek, wait, not like that, you're doing it all wrong.' For perhaps the first time they wonder about the sense of their vagabond life. It's not easy for them. Why tramp around like that? What attracts them? What's in it for them?

In the corner stand three tattered suitcases, almost empty, held together by string. What's in them? A shirt, shoes, a mackintosh, a brush missing lots of bristles. They're so penniless that they have to go to Ruda on foot. (I stayed at the workers' dormitory in Bielawa with them. 'On payday,' the porter tells me, 'they start drinking. It lasts them a week. Then they're broke. After a couple such cycles,' she goes on, 'they pack up whatever they have and disappear.')

The great industrial migration is over, but the stream still flows in waves, and these three are the spume. Young boys driven from the village by overcrowding, seekers of easier bread. Administrators complain about the trouble they have with them. They depart no one knows where and appear no one knows when. 'An unsettled element,' they say, 'enemies of discipline.'

'When the foreman got on my back, I could see it coming – time to go. I talked it over with the others and that was the last they saw of us.'

Then begin the nights in train stations, the nights on trains, the nights in barns. Workers' dormitories, barracks, attic rooms. They follow an iron rule: stick to the big factories. New building sites. Nobody knows you there, and they're afraid to ask too many questions. You disappear into the mass, melt away into the unkempt crowd. It is impermissible to grow into the tissue of any collective, to permit oneself to become entangled in a mesh of dependencies in which one starts to let one's guard down and believe that things will have to stay this way. They don't have to! Somebody says that things are better a hundred kilometres away. Better? Let's go! What do we have to lose? That surly boss? The corner of a dormitory room? What's to be gained? Everything. And they're already on the train, already on the move. Do you think that Konin can't savour of Colorado for a day? After a couple of disappointments they no

longer count on anything sensational. But the habit remains, a stupefying impulse that they submit to with inert docility.

Torn away from one environment, they cannot put down roots in a new one. They are viewed from the start with suspicion. The way you bounce around the world, brothers, your consciences cannot be clear. As soon as there's a brawl or a theft, they are blamed immediately. 'An unsettled element, enemies of discipline.' Everywhere, they are strangers who violate small-town tranquillity, the stabilization of a housing settlement, workplace harmony. They don't have to take account of their reputation, which is why their reputation is abysmal. They cannot be penalized, because they don't need anything. They do not contribute any values, yet they threaten existing values.

Are they sincere when they praise their situation?

'We don't push towards the top. We're here at the bottom, on the ground floor.'

So this is the one place they have chosen for keeps: on the margins. They change towns and factories, but they remain on the margins. This element of permanency is anchored in the fluid, swirling current of days. They camp out in this isolated spot because it's not crowded, and not even the law reaches here very often.

How they sneered at the world, this world on the make! How they mocked people who pursue the tangible goods that are generally esteemed: Mikrus cars, Belweder II TVs, SHL washing machines! If thrifty people can be said to be making their way through life, then these three are taking a side road. The workaday world has no time for their ilk. Let them sit out the game. There are enough people willing to play! The world has concluded a non-intervention pact with them – let's leave each other in peace. This is indeed a judicious attitude, of the highest humanistic order. The three *khagans* boast that they've made the right choice. They feel that outside intervention could only knock them off their chosen path. It wouldn't do any good! Perhaps somewhere they conceal a desire for those goods, but it is not ardent and imperative enough to guide their decisions. They could renounce nomadism and

choose one vocation. And laboriously line their nest. In their view, however, this would clearly be no solution.

'What's the hurry, sir?'

A lovely stretch of road connects Wolibórz and Ruda. A little buzz in the head, and the sun does the rest. This colour-filled afternoon would enchant even the immortal master, Vincent Van Gogh. The light is so intense that in a moment the air will detonate in a golden explosion. The sweat-eaten suitcase handles stick to our palms.

It's hard for people to understand each other. They'll be taking new jobs, participating in the life of a new collective, but – when they go away – will anyone be able to say a word about them? Over the course of a year, a thousand people will know their faces, only a few will know their names, and no one will know their thoughts. Reactions, not motives, count in casual contacts. They go away and so replacements must be found. They arrive, so they must be hired. Is there even any need for probing into the depths of a man? Decoding fates that he himself cannot explain? What is it that I want? I myself have nothing more to say about them. What connects us? Two kilometres of road? The inn?

A reporter is not only a megaphone into which dozens of figures, names and opinions are shouted. He'd also like to say something on his own occasionally. But what am I supposed to say? Two worlds that never intersect. Ground level. You have to live there before you can philosophize about it.

There are those who try to build higher. Even if not for themselves. But what kind of story does it take to show this? Two ranges of experience. Words are incomprehensible if you haven't lived what they describe. If it hasn't got into your blood.

'Life,' they say, 'comes down to a few concrete things: A shovel. Payday. A movie. Wine.'

What else? Is everything else an aroma diffused on the air? It is, because you can smell it, but how can you grasp it?

'*Saluto*,' one of them said in farewell.

'*Arrivederci*,' I called, so as not to be outdone.

No Known Address

He said:

Why not? A small beer, and I'll talk for what it's worth.

Have you ever been hungry? That's what I mean, fog and people in that fog. A man might as well be made of cotton wool. Hands, arms, all the rest. Please write: The boy called himself the Jack of Spades. The worst of all the Jacks. In the game of One Thousand, they only give the Jack of Spades forty points. The bum of cards. When I talk about the others, I'll call them the Jack of Diamonds, or of Hearts, or of Clubs. I might also mention a couple of Queens and a few Kings. There won't, unfortunately, be any Aces. Aha – we also have Homer. An inquisitive guy. He says: When your age equals the number of medals I hold, then we can talk. He's been through a lot, you can see that. He's worth listening to, although he's a bitter talker. Like somebody out of *Rififi*.

You want to know about the Jacks, right? That's what they call the dropouts who still hang around the university. Student *clochards*, like that sparrow out of St Francis, he doesn't plough, he doesn't sow, but he gets fed. The one called Jack of Diamonds is a real dropout. They expelled him in his second year when he failed three exams – the song was over. When they expel a student, he loses his dormitory privileges. But he has to live somewhere. He's not from Warsaw, he has no home here. Home is far away, in Olesno or Iława, and why would he go back there? To go from Warsaw back to a hole like that? Here, you understand, there are contacts, careers. Life is here. So he hangs around. In the dormitory, his friends will always take him in, give him something to eat,

and everything's OK. Except that he has no address. But is that important?

Homer always says: Boys, what kind of people are you? I see what you do. I see you, Jack of Spades, and you, Jack of Diamonds, and you, Jack of Clubs. There, on that wall on Krakowskie Przedmieście, near the intersection of Kopernika. That street, the traffic, the bustle, everybody hurrying like a panting dog, and you all sit there from morning to night. Not moving a muscle. You sit there – that's all. Do you talk – no, what's the point? Maybe you're waiting for something? No. Silent and inert. Once in a while one of you opens his mouth: I need two zloty. Who's going to chip in? They root around listlessly in their pockets. Here's a zloty, here's fifty grosz. They add it all together and they go to the kiosk. They take three bottles of beer. They pour it out into six mugs. They drink, fall silent, spit. Silence. They return the mugs. They go back to the wall. Further silence. An hour later one of them starts speaking: I have to go and take a leak. Another one pipes up: Take one for me while you're at it. I'm the boss around here, right? The day passes, and at twilight a girl walks past. The Jack of Clubs says: She's hot as a pistol, isn't she? They nod, dig around in their pockets, and – silence. Sometimes a bus pulls up in front of the Harenda Hotel. Then they all jump, they grab the tourists' suitcases and carry them. They get those five or ten zloty. That'll take care of the beer. They can keep going. That's right, I see what you live on. Beer! And the Jack of Clubs looks him in the eye and says: When somebody talks too much, they always say something they shouldn't.

The one called Jack of Clubs is a philosopher. He's a sharp one. Except he doesn't have any strength. It seems to me that none of us has any strength. Did it just slip away or what? Jack of Clubs is good at cards. An authority. You know, you have to do something in the evenings, at night. Nobody reads books, the theatre is expensive, and how often can you go to the movies? So there's cards. As much as possible – poker, bridge. Jack of Clubs has great luck. They meet up in a dormitory room, it's an incredible sight, a casino. Imagine it. Dark with smoke, the rustle of cards, a

crowd of spectators. They're playing poker, until dawn, until morning. Sometimes they play for money, but they don't have much money. So they play for cafeteria coupons, for dinners. Or for clothes. In one little room those clothes were piled a metre high. Some guy lost his sports jacket, abandoned it, bowed politely, and left. There are fanatics who wager their scholarship money as soon as they get it. Then a month-long fast follows. Well, cards are cards, gambling, no joking around. Cards are emotion, it doesn't take any effort but it's an experience. The day hasn't been wasted. Pleasure. Franek is the banker. Franek pays out, we play, July and May in the hot sand. There's a poem, but I don't remember any more of it.

When the Jack of Clubs wins, he invites us out for wine. Life is sweet, *la dolce vita*. We savour it methodically. First we march proudly to the Harenda. Two hundred in pocket – millionaires! A brief conversation around a table there, a small order, and then we make our way to the 'House at the Sign of Christ'. There's always a crowd. Have you ever been there? We have some porter and then off to the 'Chapel'. Here, the wine begins. Two glasses, a little chat, best regards to the neighbouring tables, the members of the brotherhood know each other. The requisite courtesy. The Jack of Clubs guard of honour behaves politely.

If the one called the Jack of Hearts is buying, we're the Jack of Hearts guard of honour. And so on. Only the Jack of Spades never buys. The Jack of Spades represents poverty. He's never had a guard of honour, even once. From the 'Chapel', the next stage is Fukier's. Or Café Kicha. Or the Dean's. Everywhere that acidic scent of fermentation, the smoke, the hubbub – a delight! Sometimes they go to Grandma's on Oboźna. A strange suite of rooms. An old building, a little shop, a few sweets in the display case. And abstract paintings on the walls. Works of talent. Students from the Academy give them to her for beer. Grandma extends credit. Wagon drivers sit on their parcels and drink with young women painters. A horsewhip stands in the corner, and a girl, and a dray-man. The wagon drivers have money – you know. We went in there once and a painter was sitting there crying. She was

beautiful. Everybody knows that when somebody's beautiful, they have to be miserable.

Sometimes there's a grosz left over because somebody receives something from home or for some hackwork. Some of us do printing jobs in various places and that means a few zloty. Then we buy wine and go to the dormitory. Everybody knows what happens next. Somebody tells a joke and then another one. If you know some gossip from the literary world, that's a plus. The usual stuff, you know, who's with whom and so on. The talk is mundane – so pour another one! Bam! Bottoms up! Somehow, the evening goes by. When the girls want to get good and drunk, they go off by themselves. They lock the door and whatever they do there, we don't know about it.

Homer will remark: The only time it's possible to talk with you bunch is when you're drunk. There's no life in you, no ambition, no fire. Boredom clings to you like a wet cocoon. What have you ever done in life, Jack of Hearts, you little piss-pants? What do you know about the world? Whenever I talk to you I have the impression you're asleep. You come out of it for a little wine, your beady eyes open, you take on a bit of verve, some idea starts knocking around inside your head, any minute now and your heart will start beating, and then as I look on in horror you go back to sleep. You walk, talk, make faces, laugh, but it's all done in your sleep. You doze off, the image of lethargy. It's a horrible feeling, like trying to hold on to a slippery fish. You're there and you're not there. I keep thinking where to poke you so that you'd amount to something great, something beautiful. I always used to think there was something like that in every young person. Now I'm not so sure. When Homer gets on his high horse like that, the one called Jack of Clubs has to shut him up again.

It's Jack of Clubs I'm closest to. A universal mind. You always see him with a book, always a different one. *WFM Service Manual. I'm Expecting. Introduction to the Holy Bible. One Hundred Meals for Lovers.* He doesn't read them, but he carries them around. Appearances count now. Jack of Clubs makes a good appearance. He dropped out of journalism, but he's still got the spark. You're a journalist,

too, aren't you? Fraternal spirits. Jack of Clubs writes different pieces when he's not playing poker. Over the summer he worked in the cultural field, he played records over the internal radio network. Everybody tries to do something. The one called Jack of Diamonds worked for the nuns. The nuns have a shelter for blind children in Powiśle. Jack of Diamonds chops wood there, fixes the lights, repairs furniture. Somehow he comes out ahead. Jack of Hearts was a porter. I get some jobs at the Art Academy. Different things. I scrub the floors, carry coal, beat rugs. Do you have anything for me? The Jack of Spades will take anything. Because the Jack of Clubs is an aristocrat. In general, the dropouts are an aristocracy. An elite. An exotic accent in their surroundings. We're at the top. And at the bottom – the mass of earnest students. Why do they work so hard, anyway? A student who hits the books is a misunderstanding, a tragic mistake. They work hard at the Polytechnic, but they're slobs at the Poly, upward mobility from the village, no liberal arts student with a head on his shoulders will study all the time. What – paper for recycling? They envy us! They quake before their professors, rush off to lectures, slave over their term papers – and we couldn't care less.

Of course, you have to create something. A true dropout should be creative. Poetry, plays, prose and in general literature. Fame and bread. The Jack of Diamonds sets an example. He writes stories and takes them to some room in the dormitory. If they're sleeping, he wakes them up. He says: I'll read you my new prose if you'll give me something to eat. He reads, and he always gets a piece of bread. Sometimes even with lard. Others do the same. The poets are best off. They're popular, people listen. But Homer gnaws at them: What literature is that? What do the bunch of you have to say? What truth do you aim to shout out? Jack of Diamonds, I was younger than you when two Ukrainian insurgents tied me to a tree, sat down next to me, lit cigarettes, took out a file and started sharpening a saw. They said that it was a humanitarian act because they wanted to cut me into neat pieces. I don't know how to describe that, but it's something to describe, isn't it? Have you ever seen death? Do you know what love is? Have you ever died of

longing? Been eaten up by ambition? Choked on jealousy? Wept for joy? Bitten your finger out of pain? What are you telling me? Jack of Diamonds, I know how the bunch of you live. In goose down. Go ahead, laugh, but I'm telling you: in goose down. I don't resent it, but I don't envy you, either. Once I went looking for you in the dormitory. And it was noon. I go into one room – they're sleeping. Another one – they're sleeping. The next one – sleeping. What is this? You want to write books? Make films? Tell me this – about what?

But he's going too far. Because with us, we don't so much want to make films as to be extras. It supposedly used to be like that – everybody wanted to create great things, invent marvels, be a director, govern. Now they prefer to be extras. That's enough.

There are sufficient troubles as it is. We have difficult problems. Take them in turn – how to get into the dormitory? We have no right of residence there, because we're no longer students. We have to get around that. In various ways. The Jack of Hearts and the Jack of Clubs do it like this: they go in, one of them occupies the attention of the porter, and the other one makes a run up the stairs. She takes off after him, at which the first one vanishes up the second stairwell. And they're both in. Now they have to find a room. We go around to the people we know. They like us. Everybody helps. Either there's an empty bed, or they put a mattress down on the floor. Buddies share their blankets. A great night's sleep. Sometimes the authorities stage a raid and go around at night checking up. The boys hide us in their wardrobes and cover us up with coats. If we get caught, well, that's the end and they throw us out on the street. But there are also times when one of the raiding party is an illegal dropout himself, and then he covers for the other ones. Because we all know each other.

The worst thing is feeding yourself. In the morning you have to get your hands on breakfast at the cafeteria in the dormitory. Friends give up half of theirs, and there's always bread. Somebody will always lend you money for cigarettes. Dinner is soup. You don't need a coupon for soup. You can get two bowls or, if you're

lucky, three. There's bread on the table. Somehow you fill yourself up. If not, there's beer. You can live on beer, too.

Maybe one more small one, OK? Why do you want to talk to me? I never talk like this. Or think, either. It's as if I'm thinking like Homer, but then I'd be an old fart. I'm young, right? Please tell me, because a person never knows for sure.

The Big Throw

He's always first. The one in the grey sweater is always first and that's why he has to wait. He sits down under a tree, rests his bored face on his knees, and indolently chews a blade of grass. The training field is empty – a motionless rectangle of grass inside the oval frame of the running track. So the fan in the sweater waits.

He doesn't even liven up when Piątkowski arrives. Now the fan follows the training routine. He sees how the athlete's silhouette tenses for a moment before the throw and how the discus, released from his hand, flies a flat, swift trajectory, settles to the ground, and subsides into the grass. The swing of the arm, the flight and the fall of the discus, will keep repeating for an hour, unvaryingly and monotonously. The one in the sweater sits there motionless with a wry face, but his eyes gaze attentively.

'Might as well go now: it's the same thing over and over,' I tell him.

'No, no. Let's wait. He's going to have a big throw any minute.'

So I stay, we both stay, and others who have come along in the meantime also stay to see that throw that's going to be a big one, the sixty-metre throw. We wait for it, because we always wait for something that will be big, extraordinary and splendid, that will bring us great joy and fill us with pride while also reminding us that there exists something greater than locking and unlocking the office at the same hour, collecting chicks, flattering the boss, petty swindles, loveless embraces, downtime due to poor work coordination, the songs of Rinaldo Baliński, or vodka spilled on the table.

But on the field, ordinary things are going on, the toilsome drudgework of the competitor, a workout in shades of grey, mundane, which infuriates and bores us, and yet we don't know what to do about it. The fan in the sweater starts getting impatient, the discus flies in a short arc, too short; when will the big throw happen, the sixty-yarder?

We look at Piątkowski. He's calm. That splendidly powerful youngster throws as if he didn't want to and then, at a slow pace, as if he were out for a stroll, he ambles after the discus, locates it, and throws again, without straining, without that tension that we regard as necessary for squeezing out a big throw. Someone off to the side says that he's not throwing for distance now, that he's polishing his technique. Once you've set a world record, you have to pay attention to that. But the one in the sweater keeps waiting. It's bound to happen, that one throw. What is it to Piątkowski?

No, nothing doing. The discus has stopped flying. It's lying on the track. The champion dresses and, sluggishly, slightly hunched over, walks away, the ritual concluded. Only the trainer remains, who had been sitting down until then, unnoticed by anyone. Now all those present gather around him. We walk over there. We hear the trainer saying that those last two throws were sixty metres. And so it happened! And we missed it! The fan in the sweater is embittered, he suspects a ruse. Is this just another con trick? No, those last two throws were a sure thing, a new world record, except it's a shame that it's in training, and so it's not official. The fan is consoled, but only a little, because he saw it but he didn't see it. He can say he did but he knows he didn't. He walks towards the gate, probably feeling unsatisfied, sour somehow, silent and alone.

I feel bad for the one in the sweater. I don't know him, but we've run into each other several times at this training ground. We've exchanged a few sentences. I know what brings him here. He doesn't come here to admire Piątkowski. If there's anything he wants to see, it's himself, what he never became. What he'll never be. Because the fan is one of those who, at a certain point, missed

his chance. It's not that he ever set about doing something and it didn't work out, but that he never even tried. That's the worst thing, because it leaves you permanently resentful. And you can never break free of it. People have many opportunities in life, but the chance only comes along once. You can have it, and waste it. The worst thing is that you might not even notice it. That's the big throw – it happened, and we didn't notice.

The fan talks in rather vague terms about what he does. Maybe he's a debt collector, or a clerk, or a bookkeeper. Or maybe he doesn't do anything. Probably, however, he does one of those thousands of colourless jobs from which you can't derive a spark of satisfaction. Reconciled to that anonymous existence, he nevertheless seeks, in moments of bitterness, the point at which he made his mistake. But is it really about a mistake, or about the fact that no mistake was even necessary, because nothing ever happened? Never happened? Why not? Which day was it when something should have happened that never happened in his life?

Because this Piątkowski had just such a day. He was living in Konstantynów, outside Łódź. A small town, about which there's nothing to say. He was going to school there. He was fifteen and he was a small, skinny boy. A friend gave him a discus. He started throwing that discus. He's still doing it today, eight years later. In that time he passed his final exams at school, served in the army, and is now a student at the Central School of Planning and Statistics. This is information from a thousand curricula vitae: school, work. But here we're talking about a life shaped by an absorbing passion, intransigently persistent and full.

I wondered whether he was attracted by other temptations, whether he gave in to other passions, ever wanted to try something else, or in the end was bored by that hunk of metal and wood shaped into a flattened circle. No! That fifteen-year-old boy told himself, back in Konstantynów: 'This is what I'm supposed to do. From now on, this is what I'll always do.' And he stuck to it. 'I don't like to spread myself too thin,' Piątkowski tells me. 'That doesn't make sense. I think that out of a thousand possibilities you always have to choose one, keep at it, and do everything, give

it everything you've got, to achieve a result. Otherwise, you'll hold it against yourself later that you didn't do what you wanted to do.'

The successes that come year after year are troublesome for him, because he moves awkwardly when surrounded by acclamation. Applause makes him impatient, and he's even suspicious of it: 'There's always that admiration when you're on the way up. When you start going down, the acclaim falls silent and all eyes turn away. It gets empty.'

But he's too wrapped up in his passion to dwell on people's reactions. 'These years have worked out well for me. I've made progress each year. What's the motivation? Maybe not only the idea of the record, but also curiosity – how much more can I do? How much more can I get out of myself? Where's the final limit that I can reach? Going on is increasingly difficult. But that's what's fascinating – conquering yourself. Who you might be winning out over who you are. That kind of struggle.'

He doesn't keep statistics, and he doesn't even remember the exact date when he set the world record. 'I don't even know all my results. What's past, what I've done, doesn't interest me any more. What I care about is what's now, and, even more so, what will be. What else I can do. That result that I don't have yet, which I might achieve – that's what's important.'

A man wrestling with matter, in a duel with himself: is there still time and space for something more? Years of lonely training, competition and doggedness have shaped a fighting instinct in him. Usually he's slow, even somewhat sluggish in his movements, he speaks slowly, he doesn't get excited. He has no time for cafés and parties, he keeps quiet at meetings. Larger groups make him feel inhibited. But let him walk out at the stadium, let him appear at the bottom of that roaring, red-hot bowl. He comes alive and fills with energy. His opponents do not give him stage fright and their results do not intimidate him. They don't matter to him, because he's here to get his own result. So he concentrates, thinking only of what he's supposed to do, and he keeps an eye on the still-invisible boundary he can reach. 'They say I'm so calm, but the day after a

competition I can't do anything, I walk around devastated and I feel uncomfortable everywhere.'

His career hasn't blinded him. 'You have to reconcile yourself to the fact that you start throwing worse and worse.' He doesn't panic. He will take his place in the circle again, release the discus with an infernal swing, giving it a flat, rapid trajectory, aware of the limit beyond which it cannot be thrown.

I find myself thinking again about that fan in the sweater. About him and his peers. I run into them everywhere. When they stand on the street corner looking dully around for a fight until, exasperated that nobody wants to pick one, they start up among themselves. When they sit over their glasses of tepid slurry distastefully dragging out a pointless dialogue.

'There's nothing to do.'

'Nothing. Let's go give someone a bollocking.'

But nothing comes of that bollocking. That swearing never leads to a big throw. They buy themselves a newspaper. They read an article about how Piątkowski did. 'Damn, he's lucky.' They nod and stare up at the ceiling. 'They don't understand, they don't know,' Piątkowski says, 'how much work it takes, how much drudgery. There's no room for anything else.' He's twenty-three, too. The last time I dropped in on him, he was preparing for a maths exam.

He's that age when people have a need to be something. When that's more important than everything else. That's when they look stubbornly for a model. But who's the model? Piątkowski or Tommy Steele? Maybe they can come up with some scam or hang out with the right crowd and it'll be 'Okay', as they say in English. Why work your fingers to the bone? A song, maybe a face, maybe knowing just whom to bow to – isn't that enough? That big throw – will they miss it? In Szczecin, I saw filmmakers on the street. Cameras, reflectors – they were shooting a scene. All around stood a dense crowd of young women and men. That impatient anticipation: any minute now he'll spot me and sign me up. That's what everybody wants! But they don't sign them up, somehow they fail to sign them up, and they keep filming in the ugly

part of autumn, the benches are wet, and there's nobody to punch in the face.

And so – have we missed the big throw again?

'You won't get anywhere that way,' Piątkowski chuckles when I tell him about it.

The Geezer

The road was barren. The line of asphalt dwindled away, and the air hung above it in a sweltering quiver. No vehicles. I asked the boy if he was also going to Grajewo. Yes, he was. So let's wait together. Together, all right, he said. He went on to say that he was hurrying to Grajewo because his girlfriend was waiting there. They were from Augustów. Their school year had ended a week ago. How did it go? 'I failed history,' he admitted. His teacher was a stickler, what could he say, the teacher was unrealistic and eminently inflexible. There's no way to work things out with an old geezer like that.

'What's his name?' I asked out of reportorial routine.

'His name? Stępik. Grzegorz Stępik.'

Pure coincidence. Random.

I knew Stępik. He graduated in history from Warsaw U. in 1955. 'So he's in Augustów now?' I asked. We were no more than a kilometre outside town.

I found the dinky townhouse on the market square and the cluttered little garret. I found Stępik there. It was him, of course. We sat at the table. He took out a box of matches and lit one after another. He had the same habit way back when. He lit matches while talking. He held the small wooden stick between his fingers and stared into the flame. When the match burned down, he took out the next one. On a nervous day he would go through a whole box. If a fire broke out in the vicinity, they'd probably lock Stępik up. I told him this, and he laughed. His eyes are grey, as if they were burned out in a fire. He always looks at people through the flame of a match. Does that let him see others better?

Going by appearance, he hasn't changed much. A tall stringbean of a man, and everything about him is correspondingly elongated – his legs, hands and nose. Clumsy, badly drawn somehow, which always made people uncomfortable around him.

He's twenty-seven.

Geezer.

The old geezer.

Who was it that first sniffed him out as an obsolescent relic? I ask him. He frowns and grows impatient. He cuts short our exchange. 'What's the point of talking?'

Why not talk?

All right, fine. I might well be grasping the core hidden beneath the surface. The surface is proper. Stępik teaches in school, he's up to his ears in work with lessons, teaching plans and reading lists, and he teaches as well as he can, he gives it his all, he doesn't shirk, and the school administration praises him. He sublets his place, is saving up for a motorcycle, and joins the archaeologists at their excavation every summer. From these trifles he derives his life's satisfactions, and he's happy with them. On the other hand, he does not have an iota of pedagogical satisfaction and he cannot boast of any educational success. On the contrary! Stępik is permanently facing a pedagogical Waterloo.

He assures me that he's not the only one stuck in the mud. The whole teaching staff has reached rock bottom. This is understandable. The faculty is advanced in years and it's hard for them to hit it off with the kids. The teaching staff, however, put up a united front against the students, which works to their advantage. Their corporeal attributes – grey hair, experience, their own children at the university – are also their weapons. These attributes lend them a kind of authority. People always end up listening to someone older.

But Stępik belongs to the faculty only in a formal sense. He has his chair in the teachers' room, takes his turn on hall duty, and writes his entries in the ledger. The faculty treat him condescendingly, as a junior colleague. One rung lower. An interloper from another generation. A teacher being broken in.

'It's not important,' Stępik says. 'It's no headache for me. It's about something else – I can't communicate with the kids. It's easier for me to talk with somebody half a century older than somebody five years younger.'

At the university, Stępik was an incredible firebrand. A full-blooded activist. He held meetings, consulted, instructed. The man's blood ran hot. He didn't husband his strength. He lavished it extravagantly, burning up his energy, holding nothing in reserve. He lived in something like a trance, lost in his work, and his friends had to slow him down – don't go crazy! They made up an epitaph for him:

> *Here lay Grzegorz Stępik*
> *But he didn't lie here long*
> *They dug up his grave*
> *So he could run to work.*

He studied at night, slept at his desk in the boardroom, didn't know the meaning of a vacation, and racked up mind-boggling statistics. Fifty-four meetings in a single month! People liked him for his sincerity, for his reliability, for that untrammelled, vibrant enthusiasm. He didn't care what he ate, he didn't care how he dressed, and he was on the run, talking, giving advice here, giving advice there, always hitting the top notes. The higher-ups milked him like a dairy cow. Do this, do that. He didn't know how to say no. Every failure in his life stemmed from not knowing how to say no. He loaded himself down with new burdens, new responsibilities, and he was always trying to catch up, racing, going around in circles, in a frenzy, and in the end Stępik himself was one big frenzy.

'I'm not the same any more,' he says as he strikes the match head with a snap against the sulphur. 'I don't have that spark, that verve. But back then! Remember how we held those planning sessions at night, how we kicked off campaigns, how things started slowly, how we drew people in afterwards and when they didn't want to, we told them this, and this, and this.' The matches flutter between

Stępik's fingers. He summons up those images and makes them come alive with movements of his scarecrow hands until the figures step out of the picture frame, move, walk, clap their hands, beat it into the guys' heads, beat it into their own heads. Stępik explains something to somebody, somebody explains something to Stępik, then they explain something together – and then again: images, conversations, faces, names. Stępik says it, sees it, feels it, experiences it. He gave too much of himself back then for it not to remain with him to this day – indelible, overwhelming, insistent.

And so – a geezer?

Those years burned him out, pumped him dry, washed him out. He gave a lot and he got a lot. He possesses a whole storehouse of seasoning, experience and wisdom. He will never find the energy in himself to start over. He has an established occupation, a job, and a predictable, unimpressive future. He exists in a given environment and, as an ambitious person, he would like to hold a prominent position. He lives among young people. He wants to bequeath to them his experience. He wants to impress, to be somebody, to be needed. He wants to somehow go on teaching, passing as an authority, sating their thirst.

He feels young. It's only now that he can feel young. He was too serious back then, he wasn't impulsive, he didn't build himself up. Now he clings to those whose youth strikes him as deliciously carefree, with no slitting of their wrists or saving the world.

And they pin a grey beard on him.

He's useless to them with his skills at immediate motivation, activating the indifferent, and inspiring by his personal example. Even if they manifested an honest desire to see what Stępik has to offer, would they understand the essence, function and form of the things gathered there? Would they grasp the sense of his explanations?

'For months at a time I only ate once a day,' Stępik says.

'Were you broke?' they ask, bored.

'I had some money, but who had time for food?' he explains.

They're astonished. He could eat and he didn't?

They don't understand what he's talking about. He must be kidding, they think.

'He went to all that effort, and what did he get out of it?' the boy on the road asked me. 'He never even bought himself a television set.' The boy's way of thinking is reasonable, logical, and should not be dismissed. 'As much as I give of myself, so much I'll get in return,' the wise guy calculates. All his reckoning boils down to the issue of the payoff. With the provision that the payoff should be expressed in material terms, in a quantifiable nomenclature. What could Stępik answer to that? At best, they'd suspect him of being conceited. Of groundlessly boasting. How to prove to them that they're wrong?

No film and no book could capture the fate of Stępik's generation. It has never been told. Even if that boy at the roadside were more passionate about the past than the future, it would be easier for him to understand the story of Mickiewicz's generation, or Wokulski's, than that of his own teacher. The first two are on record, but not Stępik.

The boy on the road can write a six-page paper about Wokulski – what he was like. About Stępik, he is capable of saying: Geezer.

Nothing more.

Yet they meet every day, talk, and can ask each other questions and look for answers. They don't do so.

Why should they?

'Sometimes I go to Warsaw,' he says, 'and on the streets, on the street corners, I see little groups waiting for something, as if I knew what. Or I see them getting on a tram or going into a cinema. In their attitude, in their behaviour, there's something that I'm afraid of. I prefer to steer clear of them. It seems to me that if I said: "Excuse me", they wouldn't understand the words. Those faces are incapable of expressing emotions. Those hands do not know any gentle reflexes. How do I know? That's the impression I get. I've never talked to them, though. I try to get inside my kids' heads. I can't do it. They asked me if I've read Joe Alex. I haven't. I've read Rey, but not Joe Alex. They were triumphant. There you have it – if somebody knows Rey, can they understand contemporary life? To know

what's necessary and important now, you don't need to worry your head about what used to be. Used to be – that means two or more years ago. Am I right?'

How should I know?

I listened to what he said. He struck matches and stared into the flame. He was finishing his last box when I was on my way back to the barren road.

The Loser

In the Ochota district of Warsaw they say: Losers go home. Everybody knows what a loser is. He's an odd person. He lives fruitlessly, he's always melancholy, he does not feel the passion for risk, he's afflicted with an inadequacy complex.

It's a big day at the building known as 'Peking' on Grójecka. Two of its residents, Wilczyński and Szeryk – young engineers from the Automotive Technical Service – have bought a Fiat. Now they are getting ready for a camping trip to Mazuria. I will pass over several additional names. A car is a blessing for more than its owners. A horde of acquaintances also benefit from the vehicle. The purchase of the Fiat has therefore enhanced the reputation not only of the two engineers, but also of their friends. Among them is Misiek Molak.

He goes to a party to celebrate the grey mouse now snoozing in the garage, still untested. The conversation covers tyres, moolah, making bacon and gearboxes. Highly edifying.

Misiek nudges me.

'Come on. Let's get out of here.'

On the street:

'There's no living with them. They're Talmudists immersed in the Sanskrit of technology. The world turns to a four-stroke beat, powered by a diesel engine. I can't go on listening.'

New elites are forming, he says later. If the old one was bonded by creative ambition, now the adhesive is the consumer principle. Satiate yourself, satiate yourself as much as possible with illusions, gambling, rushing around, inertia. An insanely attractive hobby. Every obstacle to this fun is suspect. They're not tolerant in the

least. They may not cast aspersions on their opponent, but instead they crush him with unrelenting indifference!

The opponent – that's him. He lays out in detail the difference between their positions, the genealogy of their enmity. They went to the same school and played on the same amateur soccer team. They were part of a group that extended over the whole district. Afterwards, he went to the university and they went to the polytechnic. The issue of political engagement arose: be active, pretend to be active, or turn up your nose? The disputes of '56, and then the split. Misiek teaches at a school, and they work in industry. Not all of them – some hold administrative posts. It's not important in the end. The important thing is how they're evolving. He's got a pack of students on his back – noisy, shallow, ephemeral. They snort while reading the Great Improvisation. He accidentally overhears two girl students: 'You dummy. Do it in a standing position. You won't get knocked up.' Life requires perpetual sacrifice – he breaks off a lecture because he sees that the class is doing a crossword puzzle.

He feels that he lost his way. Why? And at what moment? He starts looking for an answer. Not in people – he regards them as blind. He trusts books. He spends hours at a time reading. He worms his way through the libraries. Lots of titles, and more and more questions. But the quest draws him in and the journey through the shadows savours of adventure. What's around the corner with this hypothesis? What abyss lies beyond this page? You have to be careful: you're on slippery ground.

In the meantime, his friends stride across solid earth. They have a magical formula – the Big S. The S symbolizes a shock absorber. That's their programme in a nutshell: live without shocks. Don't expose your body to treacherous draughts. Weave a tight cocoon.

We already know that they work. In general, they're talented guys. Experts who keep up with what's new in their field and can sense future opportunities. On the soccer pitch, the players can be divided into those who have a nose for goal and those who blunder around. They have precisely that instinctive nose for goal. Misiek only blunders around. The crowd overlook the blunderer and keep

their eyes glued to the first kind, watching every move. That's where the scoring comes from! Szeryk's favourite saying is: 'The only thing that counts in sports is the final score. For us, too.' Misiek says that at that moment he can feel how he's sweating. All his results are in the 'loss' column.

'You loser!' they shout in his face. 'You accursed loser! Where are you going? Get on the team – we need somebody to do our fancy hand-lettering.'

He takes on a few side jobs. They even come out OK. Afterwards, it stops amusing him. He leaves the company. Because they've got a real company! Jointly planned projects, a division of labour for fulfilling their projects, an exchange of services and work. It's an authentic collective, the Loser tells me – well-oiled and efficient. If there's a chance of making money, they're capable of toiling like monks. If they have to wait for something, they have no hesitation about starving themselves. Humble slaves to their passions, they have grown numb to everything that is not directly in front of their eyes. Their minds go into action only when goaded by the spur of tangible benefits. Outside these periods they sink into complete lassitude, into such vacancy, such a moment of inertia, that they are barely capable of exchanging trivialities, let alone any kind of significant meaning.

'We don't know each other's languages,' Misiek laments.

Yet they remain in touch. Does he enjoy the role of loser? That he passes for the ultimate nobody? In some ways, he even takes it seriously. By not sharing the enthusiasms of that crowd, he can denounce them and sneer at their proclivities. The Loser doesn't throw his elbows around. He circles the vanguard like a faithful satellite, staying in its field of magnetic attraction but always remaining in an outer orbit. He knows that those closer to the centre are increasingly the ones who call the shots.

'It's strange, but I'll admit that what they are doing is right. They're creating things of worth. They have value. People are waiting for their work. No one can imagine life any more without the things they give to the world. They have a feeling for the concrete, and that's all that matters when everything else is slipping through your fingers.'

By the same token, the Loser passes sentence on himself. He bears a sort of stigma of failure. Who needs his quandaries? Where is the audience that will listen to his vexations? 'People sinking in the maelstrom of trivial problems,' he says, 'are unable to reach the surface and draw breath. The current lifts them up and the whirlpool swallows them.'

'You're exaggerating, Loser,' I tell him. 'And that exaggeration will consume you. Only the shavings will be left.'

But I'm exaggerating, too. The Loser is safe from destruction. It's nice to meet somebody like him, although he's laborious company. He draws us right into his dense fumes of sophistry, forcing our benumbed brains into action. At least we feel refreshed, however, after a series of aridly desert-like chats in which the unwitting effort seems to be directed exclusively to ensuring that not a single idea slips in among a hundred words.

He's certainly an unfashionable individual. He doesn't go on miracle diets, he doesn't follow the serialized novel *The Magic of Your Wheels*, he's not saving up, even for a push scooter. He's tormented by questions that none of those around him are even aware of. He's somebody on the other side of the window pane. You can see his face, and that it's moving, but you can't hear his voice. So he remains alone, and the solitude paralyses his volition. The Loser is full of energy, but it's in suspended animation. He has a feeling that he ought to be doing something, but he doesn't know what. When it seems to him that he knows, then the question arises: is it worth it? He gives up and makes a dismissive gesture.

He goes home. He turns on the radio. He reads some poetry, and then puts it down. He picks up Dostoevsky. (He ponders the sentence: 'It seemed to me at last that he was worried about something particular, and was perhaps unable to form a definite idea of it himself.') He lights a cigarette.

Eartha Kitt sings 'C'est si bon'.

He stares out of the window. When will they find a cure for cancer? Children are kicking a ball around. He makes tea. Tomorrow they change the movie schedule.

Eartha Kitt sings 'Let's Do It'.

He reads: 'There were, no doubt, many fine impulses and the very best elements in her character, but everything in her seemed perpetually seeking its balance and unable to find it; everything was in chaos, in agitation, in uneasiness.' That's Liza, he thinks. He goes back outside. He runs into someone. They talk. The hours pass. He sees nothing. Daydreams.

That's all.

Danka

I started at the rectory. I knocked on the massive door. The lock grated, the keys jangled, and at last the door handle moved slightly. The oval of a wary face loomed out of the shadowy vestibule and froze.

'I wanted to speak with the priest.'

'You are?'

'I'm from the press, and I travelled here . . .'

'I thought so. Of course. I understand. Unfortunately, Father is not here. I've disappointed you, haven't I? Were you counting on something spicy? My God, it could almost be funny.'

'When will Father be home?'

'Oh, that doesn't depend on you or on me. It's for others to decide. Let's not speculate.'

The face receded into the shadows, the key jangled again, the lock grated again. The rectory stood at the end of a lane that began at the town square. It stood near the lake, in a cloud of maples and oaks, two storeys high, banal and plain in its architecture. Next to it, above the tops of the trees, rose the church spire with its gallery and bell. A little house, a small, colourful cottage, squatted further on, but still within the bounds of the parish property. That must be where they lived, I thought. I approached it to check whether the windows in the cottage were broken. Yes, they were broken.

I went back into the town. I won't give its name, and the reportage will explain why. It lies in the northern part of Białystok province, and there is no one who has not seen, at least once in their life, one of a hundred little towns like this. There's nothing distinctive about any of them. They put on a drowsy face, damp

patches growing with lichens in the furrows of their crumbling walls, and anyone who walks across the town square has the impression that everything is staring at him insistently from under half-closed, motionless eyelids.

The town square is cobblestone, rectangular and empty. It's raining. All of July has been streaming with rain and people have stopped believing in summer. And the little town is dripping with rain, the roofs and the lanes and the sidewalks. A few young trees growing on the square are also dripping with rain. Under the trees stands a youngster. He's wearing a jacket in a broad check, authentic jeans and worn-out sneakers. He's standing there without purpose or hope just for the sake of standing there, just to keep going and survive somehow, like the ones who stand in front of the Central Department Store, for whom standing is a form of existence, a lifestyle, a pose, and a game.

I asked him: 'Are you from here?'

'Not now. Now I'm from Warsaw.'

'On holiday?'

'You got it.'

We went to the inn. There was a restaurant in one room and a coffee shop in the other. The smoke hung low, in woolly grey streaks. The waiter brought wine.

'What's all this about?' asked the youngster.

I started in on the business with the rectory. Maybe he knew something? Maybe he was there?

'No way,' he said. 'When I got in from Warsaw it was all over. Not much to say, just a lot of talk. The guys told me about how those old biddies went there. She's in the hospital now. She was supposedly out of this world. Legs to dream of, stacked, a pretty face, everything in the right place. Ones like that come along, and you have to move fast. I picked up a girl like that in the spring. Jesus, talk about lovely! From Śniadeckich, do you know the street? I go to the Polytechnic there. Just a kid, sweet sixteen, but wow, nothing more to say. When a man has time on his hands, that's great, but what can you do when they make you hit the books? You can't get away with it. Don't waste your time on the scandal. It's just a

shame about the girl. But people here have no orientation. Is it any wonder?'

He advised me: 'Talk to the boss of the restaurant. She always knows what's up.'

He went off and came back with the lady. She was a stout woman, dressed with exaggerated, awkward elegance. Her face was slathered with powder, rouge and lipstick. She sat down, leaning her elbows on the table and twirling her fingers in her hair.

'I went along, of course,' she said. 'My business requires it. Personally, I wouldn't have gone, but I had to for the sake of my business. If I had said no, the women would have forbidden their husbands to set foot in my restaurant. Then I lose customers and the municipal hotel takes them. The hotel has a restaurant, too. So when they started gathering in front of the house that's now being built near the fire station, I left my husband to mind the place and went there. At first there were plans to seize the priest, but he was gone because they'd summoned him to the curia. Then somebody shouted that we should go into the church and beseech God not to take revenge on us for the affront committed in his holy sanctuary. When we went inside – have you seen the church already? – that figure was standing in the middle with wood chips all around it, because she's wooden, and she wasn't ready yet. So we all knelt down, but old Sadowska jumped to her feet and screamed: "Chop her up. Chop her up and burn her. Get her out of our sight." That's what she screamed. And she ran up to that figure, and there were various mallets lying around, and a chisel and a hatchet, and she waved it around, and I felt a chill. She struck it once, but Florkowa came flying after her, the one with the son who works at the mill, and she caught Sadowska by the arm and said: "Drop that hatchet, don't you even dare to touch that figure, because it's holy." And Sadowska shouts: "Holy? She's a harlot, not holy." She said even worse things but I'm not going to repeat them. You know. And Florkowa shouts back at her: "Don't blaspheme, because hell will swallow you up and us too for condoning it." At which Sadowska turned around to face us, and we, we're all kneeling there and our legs are leaden with fear, and she cries out: "Look, you women, don't be blind.

Look, if it's not that harlot. It's her after all, may the earth cover me, it's her." And I'm telling you, but don't breathe a word because it'll be the end of me – it was her. The head, the face, the figure – the exact same. Identical. And at that moment each of us felt such dread, such madness, that none of us dared to back Sadowska up. And Florkowa stood there shielding the figure and saying, "Over my dead body. Over my dead body." And it was, sir, a beautiful day, not like today, except that in the church it was grey, gloomy, heavy with fear and the screaming of those women. Sadowska broke down sobbing, howling, and we began slipping out of the door. And what do you know, as we're leaving, out of that little cottage next to the rectory comes the girl herself. Mother of God! I, of course, I'm not backward in terms of fashion, I've been to Sopot and I myself dress *très chic*. But nobody here had ever seen anything like that. And our priest himself used to rail against depravity until it made you quake. He forbade girls to play volleyball. I myself don't know what's come over him now. I try to figure it out, but I just don't know. So that girl comes up to us and she's wearing a bathing suit, what do you call it, a bikini. A man sneezes and everything flies away. You know, sir, women don't like saying good things about each other, but I'm not backward and I'll admit that girl was like a rose blossom. Any man would go through torments and purgatory for one like her. Good Lord, sir, the women see her and you can hear them hissing. If she'd just kept going then maybe nothing would have happened, or if she'd crossed our path some other day then maybe nothing would have happened either, but we had just come out of church and there had been that scene in there that I told you about, and every one of us had a heart full of terror and bitterness that we wanted to get rid of. The girl came up to us and asked, "Are you ladies looking for somebody?" At that point Maciaszkowa stepped forward and said, "Yes. You, you pestilence!" And wham! over the head with her cane, because Maciaszkowa has trouble walking and uses a cane. And then she let her have it a second and a third time. I stood there like a stone, sir, and everything went black before my eyes and I thought: What's going on, what's going on, and my thoughts jumbled in my head like magpies in a

tree hollow. They're laying into her and I don't move a muscle. Then afterwards they went over to that cottage, smashed the windows, and dragged out the furniture and broke it up, even though the furniture belonged to the priest. At that moment I look up and I see Michał coming, that is, our church sexton. I call out to the women and they run for it, with me behind them. I already told them at the police station that my business requires me to always go with the people. I'm not backward, but I had to go.'

The police station is also located on the town square, across from the inn. It's easy to see from there what condition the regulars are in when they emerge. They can be marched straight across to the opposite side of the square, where they can sober up and recover their equilibrium under lock and key. The policeman on duty sits behind the railing observing the square, and he says: 'In general, things are calm here. But there was one incident. We never had anything like that happen before.'

'Yes, exactly,' I break in. 'I'm interested in the details.'

He smiles in a vague sort of way because he wouldn't want to talk without permission from the chief. An hour later I'm leafing through a dossier full of material that I obtained from the station chief. The chief is eagerly assisting me, suggesting names and providing addresses. I search the papers strewn across the desk and he keeps pulling new ones out of the folder.

'I state that Citizen Helena Krakowiak my neighbour came to me first, and stated enough already of these scenes of depravity spreading through the vicinity, the Lord Jesus himself drove the moneylenders out of the church thus setting an example for us. She also stated of her own accord that we give money on the collection plate, taking it out of the mouths of our children, and they fatten themselves on it in order to commit ignominy. We have already looked on this for a month and our patience is exhausted and how long are we going to look on this sight, indicated Citizen Helena Krakowiak, may their offspring go to the devil, and she crossed herself. The above-named stressed that a figure of Our Lady could have been bought for the money collected and then there would not have been an affront to morality and debauchery such as the

world has never seen. Next I would like to submit that other citizens also came to me, that is' – numerous names here – 'asserting their agreement with the above-named citizen who dropped a hint about driving out that prostitute as she expressed it because we have no need of whores in the rectory, as she also said. The above-named women stated that there was no other way out and Citizen Helena Krakowiak indicated a place near the fire station on the date of Tuesday, 28 June, at the time of four o'clock in the afternoon in order to be able to give the men and children dinner, wash the dishes and put them away . . .'

Later that day, I spoke with the secretary of the Municipal Committee. Tall and sinewy, he sat facing me, slumping his broad shoulders. He wiped his forehead, considered things, and enunciated his sentences slowly, with forethought.

'You are aware, comrade, that this might have been a provocation after all.'

'By which side?' I asked.

'By the clergy. The clergy likes doing such things whenever we try to see what they're up to.'

He stuck to this statement and refused to admit any other version. It must have been a provocation, he repeated. I didn't know the priest, but he knew him. The priest made moves that were very telling. You only had to analyse them. Their sense was clear. Perfectly clear.

We changed the subject. The new subject pleased him, and me. A factory was being built in town. They were already digging the foundations, and they were also going to build a housing settlement. The little town would get moving and play a new role. It would find its place on the economic map of the country. Even today its future already looked promising. I made a pledge to come and do a report. We shook hands and again I was walking the street, the rain was falling, the water was murmuring in the gutters, and that guy in jeans was standing under the trees on the square. It was he who suggested that I should meet with the sexton, and who led me through a hole in the fence, down a passageway and through the yard. The dwelling that we entered was crowded

with beds and chairs, and the walls were covered with pictures and satirical caricatures from magazines published in Warsaw. Two men were sitting at the table. One was older, with his arm in a sling, and the other was blond, robust and tall – his son, as it turned out. The old man stood up and went out.

'My father's sick,' said the blond man, 'his arm just won't heal. I'm staying here to help him, because we also have a little land, but I'm dying to leave for the big city!' Michał S. finished his military service and when he came home the old sexton had died, and they took him as his replacement. There's no other work to be found, at least until they build that factory. I could tell that he didn't take his position very seriously, he'd seen a little bit of the world, and would change jobs at the first opportunity.

'Are you here about that brawl?' He chuckled at my interest in it. It was starting to get dark, the rain was falling, and water ran down the windows. 'I could make tea,' Michał offered.

'It was May when he came here. I was trimming the trees. A man walks up and asks about the priest. He wasn't over thirty, dressed in a sweater with a kerchief tied around his neck, and he was holding a package. I led him into the parish office. He said hello and introduced himself. He said he was a sculptor from Wrocław. He unwrapped the parcel, and there was the head of a woman. "Take a look at it," he said. "It's a plaster sculpture of the Virgin Mary. Won't you think about it, Father?" Our old man started studying it, picked it up, judged its weight, and then said no, he wouldn't take it. The other one took the head and wrapped it back up, but then the old man told him to sit down and began questioning him about where he studied, what he was doing, whether he had had any exhibitions, and similar details. It was plain that the old man liked him, because he said: "You know, I'm not going to buy that Virgin Mary, but our little church was remodelled in the spring, we restored the side altar, and we need a statue of the Blessed Mother there. There used to be one, but the termites got to it so bad that it fell to pieces. Maybe you could do one." The other man said: "Of course", and so they went to look at the place. The sculptor figured and figured and then he said: "Well then, five thousand and it'll be

all right." The old man protested. He didn't have the money, the remodelling had cleaned him out and he couldn't give that much. They haggled until the priest tried a new tack: "Let's do it another way," he says. "I've got a cottage for the sexton here but he lives in town, and so the cottage is standing vacant. You live there, I'll feed you, and you make me that sculpture. There's a lake here, the forest, a beautiful setting." The sculptor didn't say anything, you could see that he was working something out, and then he responded: "All right, Father, but on one condition. Right now I'm working on a sculpture that's very important to me, and I can't break off. I'm doing that sculpture with a model. So I'll accept your proposal if you permit me to live here with my model." The old man was taken aback and cried out: "Here, in the rectory!?" I looked at him and I could see that he was getting cold feet. He didn't want to do it, he didn't want to do it, but he's tight-fisted and in the end he said: "It's a deal."

'They arrived at the beginning of June. That was when I saw her. She wasn't a woman. She was a miracle. Graceful, lovely, fair-haired. She introduced herself to me and said, "My name's Danka. And you?" I couldn't get the words out. My throat tightened up, I saw stars, and I thought I was dying. I mumbled something, but then I immediately thought: "Michał, strange things are going to start happening around here." And look – I was right.

'At first the old man stayed out of her way. He sat indoors and didn't come out. And she acts like she's on the beach – she strips down, blanket on the grass, and sunbathes. In her bathing suit all the time from morning till night. Believe me, you were almost afraid to look at her. Because when you looked, you wanted to cry because you were such a nothing, such an accursed zero, and you could howl until the end of the world and she'd never even glance at you. That sculptor followed her around like a puppy. He had to love her, to love her for all the men who weren't allowed to. He was OK, a very decent guy. I helped him find wood, I sharpened his instruments, and more than once I went into town to buy wine for them. We got along. As soon as there was wood, he set right to

work. He had a steady hand and he carved boldly, skilfully. That was when the old man started coming out of the rectory. He would weave in and out between the trees, and Danka was lying on the blanket. The old man wanted to get closer, but then he would immediately back away. It tempted him, but he held out. I watched him sometimes and I wanted to laugh. She would stand up and wanted to go over to him, but the old man would dash into the church. Like a game of cat and mouse. She gave him a hell of a time. He often looked in on the sculptor to see how the work was progressing. He sat down on the bench, looked around, and didn't say anything at first. Only when he started carving the face did the old man enter into longer talks with him. I would also go in to look at the sculpture, and I saw what was going on. He was carving Danka. He carved her face, her neck, her shoulders. Further down it was a long robe, but from there up it was Danka. The old man would ask if the mouth wasn't too wide. Because she had small lips, full, but small. I got the feeling that he wanted that Virgin Mary at the altar to be the image of Danka. But he couldn't come right out and say it.

'And in town it was already buzzing like a beehive. Guys came running to have a look, and the women gathered, supposedly to pray. It got busy around the rectory. Talking, rumours, speculation all at once, as you please. They kept asking me, too: "Michał, who is she?" And I told them the truth, because a person is stupid. A couple of women came as a delegation to the priest. He explained something to them and it was quiet for a few days. Then it started up again and got worse. At one point they summoned the old man to the curia, just when that sculptor went to Białystok to get a chisel. And that's when those hags came around.'

Michał S. wasn't there. Afterwards, he helped take her to the hospital. When he came back, he told everything to the one man in town who had befriended the sculptor – Józef T., who taught Polish at the school.

Józef T. (I call on him late at night) says: 'We were sitting around late in the evening. "It was at the seashore, a couple of years ago," the sculptor told me. "I was looking for a subject for my diploma

work. I wandered around the beach and the days flew by. It's easier to find a model at the beach than in the city, because people are undressed. I didn't come across anything interesting. Once I was walking along the water's edge, it was an empty spot, a fishing boat pulled up on the sand was rotting away. I went over to it, and a girl was sitting behind the boat. She asked: 'Do you have to stand right there?' 'If you could see yourself, you wouldn't ask such questions,' I replied. We were very young, and that was the prevailing form in those days. A month later, Danka came to Wrocław with me, to my garret. I sculpted her there. The title of the work was supposed to mean something, so I named the statue 'Girl After Work' and took it to the exhibition. The jury rejected it. They said it was too sacral. I was shattered, I couldn't get my bearings. I lay on the bed for hours in a complete stupor. Finally I got a crazy idea. I borrowed a cart from the doorman, packed up the sculpture and went to the diocesan curia. I told them: 'Buy this, it's a piece called "The Madonna Anticipating the Annunciation."' They conferred, but in the end they didn't take it. It was too socialist realist, they said. I couldn't stand any more. I dragged the cart to the Oder River and smashed the plaster with a hammer. Because it was plaster. When I came to my senses, I saw that the head of the sculpture was still there. I wanted to throw it into the river. I didn't do it. I took it with me. I carried it to the studio and dumped it in the corner.

."'It was only this year that I ran into Danka again. Everything was like before. 'Come on, let's go to the Mazury,' I told her. She agreed. But I didn't have a grosz to my name. Then I remembered that head. I thought: I'll take it along, I'll fob it off on some priest, and by the way I'll find a place to hole up. That's how I ended up here."'

And today is Sunday. It's raining, and the rain will probably never stop falling. A flood. A deluge. People are losing their homes. Severe economic damage. Out of the window of the little hotel I can see how, despite the puddles, the residents of the little town are coming out into the street and, in their Sunday best, walking at a dignified pace towards the square, to the inn or to the church. I get dressed and go out. I already know some of the faces. We bow to

each other. A reporter can't hide for long. So I don't duck into the hidden passageways but walk down the main street, which is busy and deep in mud.

I enter the church. In the glimmer of the candles stands a wooden statue, the figure of a lovely girl. It's an unfinished work, but the master has already managed to render the face, head and shoulders in detail. These are details of the highest order. People come up, kneel, bend their backs. I hold my head up high. I can't take my eyes off it.

Nobody Leaves

I wouldn't want to live there. There's a table covered with a check tablecloth. I wouldn't want to go on sitting at that table. There are artificial flowers with unbent wire stems. I wouldn't want to see those flowers either. Behind the wardrobe stands an axe. They gave it to me to hold so I could see whether it's heavy. Yes, it's heavy. With that weight, the axe hung over three heads. Over the small, grey head of the father. Over the head, surrounded by neat hair, of the mother. Over the crew-cut head of the son. If I don't throw it at them, they'll throw it at me, says the father. The father would like to lock the son up. The mother would like to lock the father up. The best thing would be for something to happen to them, says the son. Then life would be different. Because it can't go on like this.

. . . So as soon as I walk in, they start in on me. Immediate violence, they start in immediately. The boy is the worst. I wanted him to play for me in my old age. So I bought him a piano, I bought him an accordion. But he's not interested in music, only vodka. I thought I'd sit there in the evening and he'd play for me. He wants to play – but on my bones. She stirs that boy up against me. She says: 'Władzio, give it to him, let him know.' I can't stand it. I lie down to sleep and I don't know if I'll wake up. I have to be careful not to fall too soundly asleep, because if I fall sound asleep they'll finish me off.

. . . What's he saying? I used to weigh eighty-seven kilos and now I weigh fifty-four. That's what he did to me, my husband. At first he doesn't say anything, just paces and paces. And then, the smallest thing, and he starts. He lets out a scream. I don't fear that scream any more. But when he picks something up, then I'm scared. The

worst thing is when he picks up the axe. No telling what he could do to me. It's not about anything, it's about nothing. I've already cried my eyes out, and my hands are shaking – see? And there's no way out. My son's the only one who does anything, my son loves me.

. . . I won't let him touch my mother. Forgive me for saying it, but I won't let him touch her. If he goes after my mother, then I'll go after him. Forgive me, but that's how it is. He says that I like to drink? Well, yes, sometimes I have to drink. I'm a musician, I play at wedding receptions. A musician that doesn't drink is no musician, forgive me for saying so. Anyway, I don't need much with my tuberculosis. After a couple of glasses, I'm in a good mood. Sometimes it only takes one glass. I'm in an even better mood after some beer, forgive me. How did I get sick? Because my father chased me out and made me sleep in the kennel. Obviously from that. But I can put up with anything, that crap in my lungs, the fact that they won't let me study, I can put up with all of that, but I won't let him do anything to my mother.

. . . We know that house by heart. The old man is continually running to the police station to have them locked up because they're killing him. But he's the one who could kill them. We tell them to calm down, on orders from the police. But it doesn't do any good. Are there a lot of marriages like this? Yes, a lot. Mostly among the elderly. One big brawl, one big hell, all you can do is go and keep them apart, because as far as catching them goes, you can catch them, but there's no power that can keep them apart. Marriages like that – a lot of them. Mostly among the young.

We can put that incident with a policeman from Piastów in the spotlight and wonder how it's possible. Because the old man is a good worker. On the production line they praise him for his diligence, reliability and expertise. The old man doesn't drink and he doesn't shirk work. She's a woman of exceptional tranquillity. A fastidious homemaker. A clean house, the washing done, the floors swept. The boy's also respectable, no reports on him, never been in trouble, even though he's young. Except he's an unlucky boy, seriously ill. He ought to be receiving treatment, but how can he, because he can't leave home, so he can protect his mother? And the

mother won't leave home, so she can look after her son. And the father won't leave home, because it's his home.

They're all good people. People around here like them, appreciate them, respect them. Only when each of them is taken separately. Because when they come together, you cross yourself. Right away there's a smell of corpse. It starts with harsh words. You old beggar woman, he shouts. Me, a beggar woman? And the woman starts taking old photographs out of a box and rooting through them with nervous fingers. Here, this is my father. In a wicker chair sits an elderly gentleman with a moustache, in a good suit, with a gorgeous tie. So can I be a beggar woman? Or he says to me: You so-and-so. What do I look like, sir? He says that I'm on the lookout for younger men. Just take a look at me. So I look at that worn-out, broken-down being, and let me tell you that you'd really have to exercise your imagination to come up with the picture of those boys that she could find for herself.

And so it goes from word to word, and from those words to the axe. A merry-go-round. The whole trio are exhausting themselves, wearing themselves down, destroying themselves. There's no reason and they don't know why. And that reason that they're incapable of identifying isn't important anyway. What's important is the way of life that they've slowly become accustomed to. They're all carrying out their worthy missions, full of sacrifice. The father sacrifices everything for them, the mother for the son, the son for the mother. They all have to live because they need each other. The father is convinced that if not for him, they would starve to death. The mother is sure that if not for her, the tuberculosis would bring her son's life to a rapid end. The son believes deeply that, if not for him, his father would batter his mother to death. That's why they can't split up and depart for the far corners of the world. They're all bound together for the long run, for their whole earthly existence. There's a lot of marriages like that, the policeman tells me. Mostly among the elderly. And he repeats, pensively: Yes, a lot of them. Mostly among the young.

The Taking of Elżbieta

'Sister,' I asked, 'why did you do it, Sister?'

We were kneeling in the snow, under a low sky, with an iron grille between us. Through the grille I saw the eyes of the nun, big eyes, brown, with fever in the irises. She was silent, looking off to the side. People who look off to the side have something to say, but fear gags their throat. Then I heard her voice:

'What have you brought me?'

But I had nothing. I had neither any words nor any things. I came here alone, waded in the snow through the forest, knocked at the convent gate, and in the end stood before the steep grille bearing the one single question that I had already asked. And it had disappeared into the stiff folds of the habit, without an echo.

That is why I retorted:

'I really don't know. Perhaps only your mother's scream.'

That scream roused the village each night. Drowsy from their overheated duvets, dreams and love, the women got out of bed. They stood cautiously at the windows. They could see only the darkness. Therefore they told their husbands: 'Go and see what's out there.' The peasants stuffed their feet into their rubber boots and went outside. They walked sleepily, caressing the darkness with their hands, as if the scream were something you could take hold of like a sheaf of rye and press down to the ground with your knee. In the end, at the holy figure, they found a tall, skinny woman in an old overcoat. The woman was coughing. She had a sunken chest and was holding her arms as if she were waiting to greet someone dear to her. But she enfolded in those arms not someone's life, but her own death. She carried tuberculosis within herself. The

peasants told the woman: 'Why are you whimpering in the night? Go and sleep.' Relieved that it wasn't a murder, or a break-in, or a fire, but only ordinary pain, and not their pain after all, they returned to the warmth of the duvet, sleep, and women's bodies.

Later, that skinny woman with her shoulders in an arc was taken to the hospital, because in that scream of hers there was also blood. Now the village could sleep amidst the silence, and the peasants stopped feeling the darkness with their hands. After three months, the woman returned. People saw that her eyes were now dry and stony, and the first night they realized that there was no screaming in her lungs. The village that had previously feared the screaming now dreaded the silence. The silence drew people in like deep water. They began going around to see the woman. They entered the cottage, which was like all the other cottages in the village – with a bouquet of artificial flowers, with a tinted wedding photograph, and with a gypsum dancing girl with a daintily modelled bust. The tall woman opened the wardrobe and showed them the row of dresses hanging there. Colourful dresses, cheap and banal, because, my Lord, this was hardly Paris. She said: 'She did not permit me to destroy these dresses. She pleaded: "Mama, I'll come back."'

Then the husband of that tall woman begged her: 'Stop. Just stop.'

The man lay in bed, absorbed in listening to his own heart. His heart had been struck by a second attack, and so he lay there motionless and listened. The listening was enough to make him break out in a sweat, because it was full of tension and effort. What it feels like, Mr Reporter, is that I'm not listening to the present beat, but for the one that should come next. Will I hear it, or will there be silence?

So he lies there motionless, with hypertension – 250 – preoccupied with his own heart and nothing else, because the heart itself is a whole world, and no person can encompass two worlds at the same time. He's already lived his life, this man with two heart attacks. He's done day labour and regular jobs, and been in a camp and in prison. He and that tall woman had one child, their daughter

Elżbieta. Elżbieta was born in 1939, a month before the war. The Germans put the husband behind barbed wire, and the tall woman was left by herself. She went out to dig beets. That work exhausts your strength because the soil that beets grow in is heavy soil. The mother laid Elżbieta down between the furrows, in the shade of the lush leaves. She herself dug in the sunshine, out of breath and coughing. Her arms dropped to her side. In the evenings she made extra money by writing letters to their boyfriends for the girls. 'In the first words of my letter I wish to ask you, dear Władek, if you know whether your feelings pulse with the same sentiment as earlier but if there is no lessening in your intransigence then mine towards you is the same, of which I am informing you.' For a letter like this, she received three eggs, and if it was a letter in which the passion was supposed to explode with flaming power, then she got a hen.

The father returned after the war and, as it often was in those years, the child had to learn to say 'Daddy' to a stranger. But he was no stranger to the mother of this child. Nothing came of this meeting after a long separation. Elżbieta became an only child. She started going to school, and later to high school. The man with two heart attacks and the tall woman are simple people. They know nothing about the Platonic system or the fact that Shakespeare was great and Mozart died cursing the world. But they saw an exhibition of books in a small town and perhaps someone told them that there are people in the world who have a lot of things in their head, and that such people are treated with respect. That was why they wanted Elżbieta to study. But the man with the two heart attacks could not work, and the tall woman had only a pension. And she also had tuberculosis. It was a good thing, that woman told me, that I had tuberculosis, because when I got medicine from the outpatient clinic I sold it on the sly so that I could give Elżbieta what she needed.

Elżbieta passed her final school exam in 1957 and became a schoolteacher. A good teacher, going by her reputation. I pick up a picture taken in those days. In this picture, Elżbieta is smiling, but the man with two heart attacks and the tall woman stand there

very solemn. They are solemn because they are bursting with pride. Leave aside for a moment your admiration for the creators of electronic machines, for the constructors of rockets and the builders of new cities. Think about the mother who left her lungs to rot and the father who wore out his heart so that their daughter could become a teacher.

Elżbieta is a teacher and now she will go to university. But Elżbieta does not go to university. In 1961, she joins the order. The blow was crushing, it was murderous. The mother wandered along the road at night and the woken-up peasants caressing the darkness with their hands finally found the tall woman at the edge of exhaustion and then, relieved that it wasn't a murder, or a break-in, or a fire, but only ordinary pain and not their pain after all, they returned to their cottages and the warmth of the duvet, sleep, and women's bodies.

The tall woman was left alone. She was no stranger to solitude. Even when Elżbieta was going to high school, the sisters were drawing her in. At Elżbieta's home it was cold, the pot was empty, and her mother lay there spitting clots. At the nuns' it was warm and they fed her well. She sat there whole days.

Later I asked: 'Sister, in those times did any of the nuns ask the sister whether her mother had a glass of water at her bedside?'

She responded: 'No.'

'And did any of the nuns tell the sister: "Daughter, before you come to us to nibble at the chicken, at least bake your mother some potatoes in their jackets"?'

She responded: 'No.'

'Thank you,' I said, in order to maintain civility within the framework of general state policy towards the Church.

After her final exam, the nuns stepped up their pressure on Elżbieta. She was an affectionate girl, introverted and submissive. Her mother said there was something strange about her. She would have attacks of fear and cry.

'What did they tell her?' I asked the tall woman. They talked to her in general terms, which is always dangerous. The word condemnation, and the word eternal, and the word remember, and the

word accursed. Elżbieta came home with a fever. I recited to the mother Éluard's poem about Gabriel Péri:

> There are words that give life
> And they are innocent words
> The word fire and the word trust
> Love, justice, and the word freedom

No, she answered. None of those words. In the end, Elżbieta disappeared from home. The first letter that arrived from the convent began with the salutation 'Through Mary to Jesus!' There are several of these letters. I sense the hand of the censor upon them, but telling phrases nevertheless slip through, such as 'I beseech you O Lord to give me the grace to persevere to the end.' Or 'Have you already excluded me from your memory? I beg you not to do so.'

The tall woman wanted to fight. With what weapons can a woman like that fight? All that she had was the X-ray of her lungs. I look over that smoky image of the coal-black cavity. With that film, the tall woman travelled halfway across Poland to the convent. The Mother Superior, who was not a doctor, picked up the X-ray, looked it over, and burst out laughing. 'There's nothing there!'

The mother came home but her husband was gone. Her husband was in the hospital. He had suffered that second heart attack. The doctors doubted that he would make it. The mother sent Elżbieta a letter, asking her to come at once. But Elżbieta never showed up. The letter was not delivered to her. Instead of her, two nuns appeared in the hospital where her father lay unconscious, to check whether there was really anything wrong with him. 'Is one of you sisters the daughter of the patient?' the department head asked.

'No, we've been sent here,' they replied, and withdrew their faces into the shadows of their starched wimples.

And so the mother sent a letter to the Primate of Poland. I read that letter, too. I also read the reply. It is a little correspondence form, on the letterhead of the chancellery of the primate, which states that 'accusations directed at this office are untrue and we

advise you to keep quiet'. It strikes me that this is not bad advice. After all, it's a good thing to remain quiet in cases of tuberculosis and heart trouble. I also think that centuries of experience have gone into this reply, and that it's even known what kind of experience this has been. I may also think one thing or another, but what I think has no significance here. I can say that I feel sorry for that tall woman and that man with blood pressure of 250. I feel sorry for those peasant men whose sleep was interrupted and who went out caressing the darkness with their hands, as if the scream that came out of the darkness were something that could be grasped in a handful like sheaves of rye and crushed down on the ground under their knees. That woman and that man did not have much of a life, although they gave it their lungs and their heart. After that, they tried to fight. But when solitary people try to fight for their cause, it is only at that moment when they naively forget that right must yield to might. In the end, that moment always passes. And what's left is what's left.

That is why I told Elżbieta: 'I really don't know what I've brought you. Maybe only your mother's scream.'

And that scream, which after all cannot be taken by the handful like a sheaf of rye and pressed to the ground under your knee, seems to me something completely real. I could hear it, see it and touch it. It was authentic, even if it lasted but a moment. Many people heard it and those people knew why that tall woman screamed. Those people could reflect upon it. And that's a lot, if you really do reflect upon it.

Standing at the grille, Elżbieta and I were silent. Nuns started coming down the stairs. First there were three of them, then five, and finally I stopped counting. They moved Elżbieta to the rear. In the end I couldn't see her. I saw many unmoving faces, but the face of Elżbieta Trębaczyk, a teacher from outside Kalisz, was gone.

And so I turned around and walked back in the snow, through the forest, to the station.

Us against the Trees

At first we didn't like it, but later we got used to it. Later, after we wiped the warm sweat away with our sleeves so many times, after we polished our boots to the point that the sun extinguished itself out of envy, after we dug trenches one-two-three, when these and many other things were behind us, all that crazy drilling, that whole tempestuous metamorphosis that changed one civilian after another into a soldier until our hearts were bursting! And despite this we couldn't make the lieutenant happy. 'Troops!' he complained in front of our taut rank. 'With troops like this you wouldn't get very far!' Yet he never confided exactly where he'd want to get to with us. But we knew that he was speaking rhetorically: there was nowhere to go.

We were surrounded by the forest. That forest was immeasurable, impenetrable, unfathomable. It must have ended somewhere, there must have been a boundary to it, but we never got to the edge of the trees. We saw only the forest and we lived within it, in brick barracks with a corridor on the right going all the way to the end. We didn't like the trees, the smell of them, their predatory branches and treacherous roots, but above all we didn't like their almost bureaucratic indifference, their stony immobility, the mocking laziness that they maintained when we – with much shorter lifespans than theirs – had to waste our time on frontal marches, on cleaning our weapons and singing the song 'They sa-a-a-ailed over the ocean and waves'. The trees were always against us. They obscured the sun and dropped snow down our collars. They led us astray and allowed our opponents to set ambushes. They knocked their branches against the window panes and howled all night so

that they haunted our uneasy sleep. We cursed the trees. They imprisoned us in their labyrinth and obscured the sight of the boundary beyond which began that other world.

We all shared the same opinion of the place where it had befallen us to serve. Orders, tasks, clothing and even the food made us resemble each other. Aware of the uniformity that was mandatory here, we knew that it covered not only how we dressed, but also our gestures and our words, and perhaps even our thoughts. You don't put on a uniform as a child. You have years of life behind you, in which you have learned good things and bad, wise and idiotic. Everybody has learned something different, and to varying degrees. Along the way they've acquired various customs, habits and manners. All of this makes up positive or negative individuality, outstanding or mediocre. People value the fact that they're different from others. And they especially love their own ways. When they find themselves in a barracks, they have to give them up. It's understandable that they drag this out, that this diminution is a painful, drastic process.

We had that behind us. We discovered with awe characteristics within ourselves that should have pleased the lieutenant. 'What are you doing, going to bed,' one said to another, 'when you've got a dirty rifle?' We were soldiers – say what you will.

But those shared thoughts, reactions, and moods of ours fell apart at the edge of the forest world. When our imagination ran beyond that world, all of us again became someone else and – I dread these words – strangers to each other. That external world, which had shaped us and waited to receive us back, presented itself to us – in contrast to the military standard – as a planet with an unheard-of wealth of landscapes, colours, sounds and scents. Life there was something we could all fathom for ourselves: joys and sorrows, rain and sunshine, the tram, the sputnik, the first snowdrop flower, Chopin's *Études*, a woman in bed, the film *Le Salaire de la peur*, Utrillo in his white period, a quarter litre of pure spirits in one gulp, a walk with the kids, a bumper crop of wheat in the summer, Lollobrigida's bust or Hanka's, Kryśka's or Stefa's, farewells and homecomings, Berlin, Nasser's plans, a washing machine, an

argument with the boss, a pair of presentable boots for 340 zloty, jealousy, an engineer's diploma, the death of an uncle, a bathtub full of hot water, an annual miner's bonus, a mug of beer, once again you're mine, the *Dictionary of Foreign Phrases* (second edition), a person walking down the street.

That world drew us in or outraged us, but everything in it was tangible, had a nature of its own that we could somehow connect with to create new values or alter the character of existing values. Everything there pulsated, shifted its location, and submitted to the eternal laws of motion and energy. There was a lot of light out there for which we, doomed to the gloomy shadow of the forest, longed. Many desires and many satisfactions, temptations and disenchantments – everything that goes to make up the life deliberately or involuntarily given to us.

Escaping together to that world, we already knew how it would differentiate us. Instinctively, we looked around at each other: That one will go back to being a farmer, that one an engineer, that one over there a manager and the other one a janitor. When would we meet again? And in what circumstances?

We were friends. We had exchanged vows in the school of adversity. We had extirpated the evil in ourselves and that had sometimes been a painful operation. There was no living outside the collective. But entering that collective meant contributing some value, something that would enrich the others, that would be useful. The world beyond the boundary of the forest beckoned, but we were fated to exist among the trunks, under the green canopy of branches, and we had to make that existence tolerable and palatable.

We sometimes got irritated. 'Man was once free,' we would say. 'He could hang out wherever he wanted and as he wanted. After work, his time was his own. All over the world, time belongs to people. Everyone can choose what to do with it.'

'Not everyone,' someone suddenly protested. 'Soldiers can't. Nowhere.'

It was evening and the woods, tormented by a gale, were acting up horribly. We thought about other soldiers. About the common

soldiers in all the world's armies. About our Bożym who was on sentry duty that infernal night, about Vanya who was now buffing his automatic in Chukotka, about Fidel Castro's soldiers who were drinking themselves into a stupor that evening because they had had a hell of a workout. We thought about the Indian riflemen standing in line for the soup kettle, and the Ghanaian conscript scouring the swamp with his belly on the command: 'Hit the dirt!'

We, the rank-and-file soldiers from all over the world, are the ones who get up at the same time and do calisthenics at every degree of geographical longitude, shoot at dummies, hitting or missing them, march without knowing where to or why, make a tight bed, clean the latrines, yearn for a pass, answer: 'Yes, sir!' and salute according to regulations written in the most varied languages.

We understand the paradox that we are caught up in: we are carrying arms, while people dream of a world without a single rifle. We also know that we stand under different flags. That borders and systems divide us, and that for this very reason there can be no brotherhood among us despite the fact that we share the same barracks existence, an identical necessity of obeying, and the duty imposed by the uniform.

In the morning we went out on the training ground. It was located in a large glade that had been completely churned up by older recruits honing their sapper skills. We also furrowed that glade industriously. The lumpy ground did not want to yield and we had to drive our pickaxes into it. We had trouble digging a line of trenches. Before we even started on that, however, we had to choose a position.

The man entrusted with this role stepped forward and said impetuously: 'Our defensive line will run from that bush to that stump.'

We liked his choice. We thought it would be the best position to fight from. But the lieutenant was disgusted.

'Give me a break,' he said. 'You can't do it that way. You have to crawl that line on your gut, metre by metre. You can't stand up – after all, the enemy's firing. The bullets are flying and people are dying. Imagine it,' he urged.

But that was what we couldn't get into our heads. Not then, and not at any later point. We were not able to imagine warfare. We looked around. The forest was soughing, white fluff carried on the wind, the glade was silent, and at the bottom of it our boots crunched in the snow. Our imaginations could not give birth to any images of terror and struggle. We were unable to evoke even the vaguest vision of collective slaughter, the scraping of bayonet against bone, or human scraps in a puddle of sticky blood. All we saw was the forest, the glade and the snow. Nothing more.

Was this mental laziness? A particular kind of passivity, fatigue and apathy? I'm trying to find an explanation, because it makes me wonder. Perhaps some instinctual protest arose in us against setting a panorama of war in this landscape. Some kind of biological resistance against seeing ourselves – even in our mind's eye – with bullet holes in our skulls, with our legs blown off. I think, however, that this lack of military imagination stemmed from a certain disbelief in the possibility of the kind of situation that the lieutenant wished to present to us. Secretly, we imputed a certain naivety to him. We had the conviction – which we had absorbed from the writings of politicians and scholars – that in the event of a conflict, the world was in danger of annihilation. There could be total destruction on an almost cosmic scale. This, too, we could not imagine, but in our lack of scientific knowledge we spun unfettered fantasies. In our discussions we managed to establish that an eerie death would await us, a death like something in a laboratory. Some kind of chemical process, instantaneous and terminal, would take place – something in the form of a blast or an invisible change in the composition of the air, and we would melt or evaporate. What was the use of trenches, barbed wire or camouflaging our firing positions?

Would it matter then that we had given our boots a regulation shine? That we had the correct number of rounds in our ammunition belts? Would there be enough time to check? That was what tormented us. We knew the warnings issued to the world by the scholars and politicians: Don't have any illusions. This war will not come down to a clash of bayonets. Its style and techniques have no

historical parallel. The fact that both sides possess weapons of mass destruction places a question mark over using experience gained in the Second World War or all the wars recorded in the annals. This is confirmed by dozens of books written by the highest authorities. Where does the truth lie? Perhaps the authorities are wrong and the lieutenant is right. Perhaps they're both right. We'd really like to know. But it was not the time for asking questions. We dug away at the trench, wondering in spite of ourselves whether it would save us.

Military technology is the most highly developed technology in the world today. Every great scientific discovery immediately falls under military secrecy, which is like a bushel basket. Humanity is defending itself against total annihilation. It dominates humanity's consciousness. One of us tells about something that happened in his small home town. There was a textile mill there. The employees were village girls. On the day of the American intervention in Lebanon, they stopped working and went home. The same thing happened during the Taiwan conflict. The girls would not even be able to find Lebanon on a map. Is it far away or near? On what continent? Wherever in the world fighting breaks out, the smell of gunpowder reaches our nostrils. Specialists have increased the range of missiles, and rockets can circumnavigate the equator in a fiendishly short time.

We common soldiers, armed with shovels and rifles, wanted to find our place in this new world, the world of total danger, in the world of a thousand nuclear bombs, electronic anti-aircraft artillery and remotely guided missiles.

In the meantime we dug our trenches. And though it might not have been the right thing to do, we soon went back to our regular, everyday thoughts – about peace, not war.

Sometimes the lieutenant led us through the forest for hours. He deliberately strayed along the fire breaks and we, using a map, had to locate the place where he ordered a halt. They called it 'finding the place where you're standing'. Your place on earth. It was an easy enough exercise, we had precise maps, and we had learned how to do it.

During this activity my neighbour in the ranks, Grzywacz, spoke up: 'See how easy it is. I draw three lines and their intersection is the desired point. Here I am. In this corner of the globe stands Private Kazimierz Grzywacz. He has found his place in the world. Lord, if only it was like that in life. That easy to find a place for yourself in life.'

With that sigh, he bared his secret. He had volunteered for the army. 'They'll get me into shape here,' he promised himself.

That's what he needed. He lived in Szymborz, a small Silesian town. He finished school and had a short stint at some technical school, but had to drop out to take a job and help his mother. He started in a stone quarry, but it soon closed down. He moved on to a match factory, but irritated the foreman and was fired. He tried to set himself up in Wrocław, but it didn't work out. His life, the life of Grzywacz, was a failure. No stabilization and no normalization. People climb to the top or settle for something small but stable; he, on the other hand, was nowhere. He was neither a hooligan nor an enthusiastic gadabout. Just unlucky, just a washout. At some point he had gone off course and couldn't get back on track.

Grzywacz liked it in the army. Somebody thought about him, gave him things to do, and looked after his stomach. But above all, Grzywacz's previously undefined existence took on form. He stopped worrying. He got rid of the sense of uncertainty that had filled him and ruined all his joys.

By nature he is a doer in desperate search of a boss. He doesn't know how to make decisions, choose, take risks – at such moments he looks around for someone to do it for him. Having found that person, he is as obedient as a dog and boundlessly devoted. He reacts to orders instinctively and goes into action unthinkingly. Nevertheless, he is continually in need of an external stimulus to motivate him. Otherwise, he loses his equilibrium and goes around despondent. Because of these character traits, Grzywacz is a constant source of the conflicts that the platoon occasionally experiences. People here retained a dose of scepticism carried over from civilian life, a certain restraint and even something like reserve – do what you must, but why exceed the quota? The

execution of orders was not accompanied by that internal tension that prompts people to act with the utmost zeal. Standing out in a positive way was seen in some quarters as an irrefutable sign of sycophancy, and standing out in a negative way as haplessness and incompetence. According to these philosophers, the correct thing was to maintain a sense of proportion, not put oneself forward, and take advantage of that anonymity conferred by a uniform and a cap pulled down over one's eyes.

Grzywacz went too far. When we were practising in skirmishing formation, he would take the lead and the panting, worn-out men would curse him because they had to speed up. He performed the chores involved in barracks duty so quickly and with such exactitude that our own efforts looked poor, if not disgraceful. The philosophers rebuked the fanatic. 'What's the hurry,' they asked, tapping themselves on the forehead. They didn't want to see that Grzywacz had at last found his calling, his element. That he had come alive, gained self-confidence, and felt solid ground under his feet. The philosophers were bilious, and they found the joys of life – so beautiful and alluring – distasteful. In contrast to Grzywacz, they held up Hryńcia as an example.

We had to calculate the angle at which the ridge we were standing on sloped down in relation to ground level. There is a formula for that angle, and the whole problem can be solved in half a minute. The lieutenant gave us three minutes and, of course, we finished before that. But all that Hryńcia managed to do was to sign the paper. In the blank place where the calculation should have been, the lieutenant gave us 2 marks out of 5.

'Where were you raised, Hryńcia?' he asks.

'In the wilderness, sir.'

Laughter and an exchange of meaningful glances. But it's the truth. Hryńcia is from Białowieża. In a hamlet lost in the trackless country, he farms a plot of land and distils homebrew. He's always inviting us for that homebrew. We have to go there on the spot, because Hryńcia's product tastes best when fresh. He once had a barrel of mash break open. Two wolves lapped up the deadly slurry and fell dead. He got 2,000 from the government for them. So he

also has income on the side. Hryńcia is a scammer among scammers, but in the peasant style, not the Warsaw one. This is why his cunning is quiet, intuitive, unostentatious, and not a pose. All Hryńcia's efforts revolve around getting out of the army and back to the hamlet.

'The hay's growing there with no one to gather it, sir. Right now the ground's frozen and you can cart it out, because it grows in a marshy meadow. When it's warm, you can't drive a cart in there.'

All his badgering is in vain – the lieutenant can't discharge anyone.

'What am I doing here, sir?' Hryńcia pleads. 'I'm too stupid for this learning. I'm illiterate. I had three years of schooling before the war, but what do I know how to do?'

He doesn't know how to do anything. He can barely sign his name, and he can't read a newspaper. With the doctor, he tries to feign ear trouble. 'When they say: "Here you are", you can hear it, but when they say: "Give it to me", you can't,' the doctor laughs. Hryńcia is dull, but, most of all, he's not interested in learning anything. When it's time to study and everybody pores over their notes, he opens his exercise book to a blank page and sits there. He snoozes or his mind wanders. 'Why aren't you studying?' we ask. 'It's all beyond me,' he answers. At the blackboard, he pretends to be a total blockhead.

'Draw angle A,' says the lieutenant. Hryńcia stands there. 'Why aren't you drawing it?'

'Do you think I know what that angle is?'

After a certain amount of time, he achieves his aim. They stop asking him questions, they stop bothering him. Everybody knows – a peasant from the wilderness, illiterate, what do they want from him?

From then on, he has a great existence. In the middle of the twentieth century, which is imbuing life with increasingly head-spinning technology and advancing the scope of knowledge, the century of sputnik, television and cybernetics, Hryńcia is winning by going against the universal trend. He doesn't want to take part in it. He doesn't even want to know what it's about. He almost closes his eyes, he almost stops his ears. He's a little bit afraid of one

thing – these novelties are beguiling. Once people see them, life in his village – with no lights, with no tractor, with five children in a single room – will start to seem confining and become unbearable. Better not to get infected with these city things. Hryńcia wants to go back to his land, to the plough and the homebrew, to that hay growing in the marshy meadow that could be gathered now when the ground's frozen, because when the warm weather comes you can't drive a cart in there, and it rots.

Grzywacz and Hryńcia were the extremes of the platoon, the two poles who between them embraced all the rest, the average ones. Not that there were no shades of grey. In the army, individual character defines itself quickly. There are so many situations that verify a man's worth.

When we left the barracks for good, it seemed to us that we would never go back there, not even in our minds, and that the end of our friendship was irrevocable. But no! We hang on to each other's addresses, we remember names, and it happens that we spot each other's faces in the crowd. We start talking. Then the streets, the buildings, and the passers-by fade away and the rustling of the trees drowns out the noise of the city. Once again there's the forest, the immeasurable forest without end, with no way out, a green world, the bracing pine fragrance, the sap circulating in the tree trunks, the treacherous forking roots – and us, lost and silent, with rifles in the crooks of our arms.

The Stiff

The truck is racing through the dusk, its headlamps, like a pair of eyes, searching for the finish line. It's close: Jeziorany, twenty kilometres. Another half-hour and we'll be there. The truck is pushing hard, but it's touch and go. The old machine wasn't meant for such a long haul.

On the flatbed lies a coffin.

Atop the box is a garland of haggard angels. It's worst on bends: the box slides and threatens to crush the legs of those sitting on the side rails.

The road bends into blind curves, climbing. The engine howls, rises a few notes, hiccups, chokes, and stops. Another breakdown. A smeared figure alights from the cab. That's Zieja, the driver. He crawls under the truck, looking for the damage. Hidden underneath, he swears at the perverse world. He spits when hot grease drips onto his face. Finally he drags himself out into the middle of the road and brushes off his clothes. '*Kaput*,' he says. 'It won't start. You can smoke.'

To hell with smoking. We feel like crying.

Just two days ago I was in Silesia at the Aleksandra-Maria coal mine. The story called for an interview with the director of the workers' dormitory. I found him in his office explaining something to six stocky youngsters. And I listened in.

This was the problem. During blasting, a block of coal had fallen and crushed a miner. They managed to dig out the body, but it was badly smashed. No one had known the dead man well. He had been working in the mine for barely two weeks. His identity was established. Name: Stefan Kanik. Age: eighteen. His father lived in

Jeziorany, in Mazuria. The management contacted the local authorities there by telephone. It turned out that the father was paralysed and could not travel to the funeral. The Jeziorany authorities asked if the remains couldn't be transported to the home town. The management agreed, provided a truck, and assigned the director of the workers' dormitory to find six people to escort the coffin.

These are the ones who have been summoned.

Five agree, one refuses. He doesn't want to lose any overtime. So there's a gap.

Can I go as the sixth?

The director shakes his head: a reporter as a pallbearer? A hell of a mess.

This empty road, this wreck of a truck, this air without a wisp of breeze.

This coffin.

Zieja wipes his oily hands with a rag. 'So what next?' he asks. 'We were supposed to be there this evening.'

We are stretched out on the edge of a ditch, on grass coated with a patina of dust. Our backs ache, our legs hurt, our eyes sting. Sleep, uninvited, introduces itself: warm, companionable, ingratiating.

'We'll sleep, boys,' Wiśnia says weakly, and curls up into a ball.

'And so?' Zieja says, surprised. 'Are we just going to go to sleep? But what about that other one?'

He shouldn't have mentioned it. Embarrassed by the question, sleep becomes awkward, backs away. We lie there in the torment of our fatigue, and now we are also anxious and uncertain, staring dully into a sky where a silver school of stars is swimming. We have to make up our minds.

Woś says: 'Let's stay here till morning. In the morning one of us can go into town and borrow a tractor. There's no need to hurry. This isn't a bakery.'

Jacek says: 'We can't wait till morning. It would be better to get this over with quickly, as quickly as possible.'

Kotarski says: 'You know, what if we just picked him up and carried him? He was a little guy, and a good bit of him is still underneath

that block of coal. It's not much of a load. The job will be done by noon.'

It's a crazy idea, but it's one everyone likes. Put your shoulder to the wheel. It's early evening, and there aren't more than fifteen kilometres to go. We'll make it for sure. Besides, there's something else. Crouching on the edge of the ditch, having overcome the first temptation of sleep, more and more we feel that with this coffin literally hanging above our heads we are keeping a vigil, here in the deep darkness, amid shadows and bushes and the silent, deaf horizon: the tension of waiting for the dawn would be unbearable. It would be better to go, better to lug him! Take some sort of action, move, talk, vanquish the silence emanating from the black box, prove to the world and ourselves, and above all to ourselves, that we belong to the realm of the living – in which he, nailed in, the stiff, is an intruder, an alien, a creature resembling nothing at all.

At the same time we find ourselves looking upon the task ahead – this arduous carrying – as a sort of offering to be presented to the deceased, so that he will leave us in peace, freeing us of his insistent, cruel, and stubborn presence.

This march with the coffin on our backs has got off to a rough start. Seen from this viewpoint, the world has shrivelled to a small segment: the pendulum legs of the man ahead, a black slice of ground, the pendulum of your own legs. With his vision confined to this meagre prospect, a man instinctively summons imagination to his aid. Yes, the body may be bound, but the mind remains free.

'Anybody that came along now and ran into us would sure make tracks.'

'Know what? The moment he starts moving, we drop him and take off.'

'I just hope it doesn't rain. If he gets waterlogged, he'll be heavy.'

But there is no sign of rain. The evening is warm and the enormous, clear sky soars above an earth that is asleep now except for the sound of the crickets and the rhythmic tramping of our steps.

'Seventy-three, seventy-four, seventy-five' – Kostarski is

counting. At 200 steps, we change. Three move to the left, three to the right. Then the other way around. The edge of the coffin, hard and sharp, digs into our shoulders. We turn off the paved road onto a forest track, taking a short cut that passes near the shore of the lake. After an hour we haven't done more than three kilometres.

'Why is it,' Wiśnia wonders, 'that someone dies and instead of being buried in the ground he hangs around and wears everybody else out? Not only that. They all wear themselves out just so that he can hang around. Why?'

'I read somewhere,' Jacek says, 'that in the war, when the snow melted on the Russian battlefields, the hands of the dead would start to show, sticking straight up. You'd be going along the road and all you'd see would be the snow and these hands. Can you imagine, nothing else? A man, when he's finished, doesn't want to drop out of sight. It's people who hide him from their sight. To be left in peace, they hide him. He won't go on his own.'

'Just like this one of ours,' says Woś. 'He'd follow us round the world. All we have to do is take him along. I think we could even get used to it.'

'Why not?' Gruber quips from the back of the coffin. 'Everyone's always bearing some burden. A career for one, rabbits for another, a wife for a third. So why shouldn't we have him?'

'Don't speak ill of him, or he'll kick you in the ear,' Woś warns.

'He's not dangerous,' Gruber says softly. 'He's behaved himself so far. He must have been OK.'

But in fact we don't know what he was like. None of us ever laid eyes on him. Stefan Kanik, eighteen, died in an accident. That's all. Now we can add that he weighed around sixty kilos. A young, slender boy. The rest is a mystery, a guess. And now this is the riddle that has taken on such an unseen and unknown shape, this alien, this stiff, ruling six living men, monopolizing their thoughts, wearing out their bodies, and, in cold, impenetrable silence, accepting their tribute of renunciation, submission, and voluntary consent to such an oddly formed destiny.

'If he was a good guy, then you don't mind lugging him,' says Woś, 'but if he was a son of a bitch, into the water with him.'

What was he like? Can you establish such facts? Yes, certainly! We've been lugging him for about five kilometres and we've poured out a barrel of sweat. Haven't we invested a great deal of labour, of nerves, of our own peace of mind, into this remnant? This effort, a part of ourselves, passes on to the stiff, raises his worth in our eyes, unites us with him, our brother across the barrier between life and death. The feeling of mutual strangeness dwindles. He has become ours. We won't plop him into the water. Sentenced to a burden we feel increasingly keenly, we will fulfil, to the very end, our mission.

The forest ends at the edge of the lake. There is a little clearing. Woś calls for a rest and starts to make a bonfire.

The flame shoots up immediately, impudent and playful. We settle down in a circle and pull off our shirts, now wet and sour-smelling. In the wavering, pulsating glow we can see each other's sweating faces, glistening torsos and red, swollen shoulders. The heat spreads from the bonfire in concentric waves. We have to back away. Now the coffin is closest to the fire.

'We'd better move that piece of furniture before it starts to roast and begins stinking,' Woś says.

We pull the coffin back, push it into the bushes, where Pluta breaks off some branches and covers it up.

We sit down around the fire. We are still breathing heavily, fighting sleep and a feeling of unease, baking ourselves in the warmth and revelling in light miraculously conjured from the darkness. We begin to fall into a state of inertia, abandonment, numbness. The night has imprisoned us in a cell shut off from the world, from other beings, from hope.

Just at that moment we hear Wiśnia's high, terrifying whisper: 'Quiet. Something's coming!'

A sudden, unbearable spasm of terror. Icy pins stab into our backs. Against our will, we glance towards the bushes, in the direction of the coffin. Jacek can't take it: he presses his head into the grass and, exhausted, sleep-starved, suddenly afraid, he begins to weep. This brings us all to our senses. Woś comes to himself first and falls upon Jacek, pulling at him and then pummelling him. He

beats him fiercely, until the boy's weeping turns to groans, to a low, drawn-out sigh. Woś backs off at last, leans on a stump, and ties his shoe.

In the meantime the voices that Wiśnia detected become distinct and draw closer. We can hear snatches of melody, laughter, shouts. We listen attentively. Amid this dark wilderness our caravan has found traces of mankind. The voices are quite close now. Finally we pick out the silhouettes. Two, three, five.

They're girls. Six, seven.

Eight girls.

The girls – at first afraid, uncertain – end up staying. As the conversation gets off the ground, they start settling down around the fire next to us, so close that we could reach out and put our arms around them. It feels good. After everything we've been through, after a day of hard travelling, an exhausting march, the nerve-wracking tension, after all of this, or perhaps in spite of all this, it feels good.

'Are you coming back from a hike, too?' they ask.

'Yes,' Gruber says, lying. 'Beautiful evening, isn't it?'

'Beautiful. I'm just starting to appreciate it. Like everyone.'

'Not everyone,' Gruber says. 'There are some who don't appreciate anything. Now or ever. Never.'

We're all watching the girls closely. In colourful dresses, their shoulders bare and sun-bronzed – in the flickering light golden and brown by turns – their eyes seemingly indifferent but in fact provocative and vigilant at the same time, accessible and unreachable, they stare into the blazing fire and appear to be surrendering to the strange and somewhat pagan mood that a night-time forest bonfire evokes in people. Looking upon these unexpected visitors we feel that, despite the numbness, sleepiness and exhaustion, we are slowly being filled with an inner warmth – and, while wanting it, we sense the danger that comes with it. The edifice that holds in place the purpose and justification for making this extraordinary effort on behalf of a dead man is suddenly tottering. Why bother? Who needs it when an opportunity like this presents itself? Only negative feelings link us to the dead man: in our new mood we

could break away from the stiff so completely that any further toil of carrying the coffin would strike us as downright idiocy. Why make fools of ourselves?

Woś, however, has remained gloomy after the incident with Jacek, and has not joined in the flirting. He draws me aside.

'There's going to be trouble,' he whispers. 'One or the other of them is sure to go off after a skirt. And if we're a man short, we won't be able to carry the coffin. This could turn into a stupid hassle.'

From this remove, our calves almost touching the sides of the coffin, we watch the scene in the clearing. Gruber will go for sure. Kotarski, Pluta – no. And Jacek? He's a question mark. He is, at heart, a shy boy, and wouldn't initiate a thing unless the girl made the first move: he'd turn tail at her first 'No.' Yet because his character affords him few chances, he would grab avidly if one presented itself.

'It's a dead cert Jacek goes,' Woś says.

'Let's get back to the fire,' I tell him. 'We're not going to solve anything here.'

We return. Pluta has thrown on some more wood. 'Remember, it was autumn,' the girls are singing. We feel good, and we feel uneasy. No one has breathed a word about the coffin, but the coffin is still there. Our awareness of its existence, of its paralysing participation, makes us different from the girls.

Stefan Kanik, eighteen. Someone who is missing and at the same time is the most present. Reach out and you can put your arm around a girl; take a few steps and you can lean over the coffin – we are standing between life at its most beautiful and death at its most cruel.

The stiff came to us unknown, and for that reason we can easily identify him with every boy in the world we have ever happened to meet. Yes, that was the one, that one for sure. He was standing in the window in an unbuttoned checked shirt, watching the cars drive past, listening to the babble of conversations, looking at the passing girls – the wind blowing out their full skirts, uncovering the whiteness of their starched slips, so stiff that you could stand

them up on the floor like haystacks. And then he went out into the street and met his own girl and walked with her, buying her sweets and the most expensive lemon soda – Moorish Delight – and then she bought him strawberries and they went to the movie *Holiday With Monica*, in which an actress with a difficult name undresses in front of an actor with a difficult name, which his girl has never done in front of him, not even once. And afterwards he kissed her in the park, watching from out of the corner of his eye from behind her head, through her careless loose hair, to make sure that a policeman wasn't coming who would take down his name and send him to school, or would want twenty zloty when they didn't have more than five between them. And afterwards the girl would say: 'We have to go now', but she wouldn't get up from the park bench; she would say: 'Come on, it's late', and she would cuddle against him more tightly, and he would ask: 'Do you know how butterflies kiss?' and move his eyelids close to her cheek and flutter them, which must have tickled her, because she would laugh.

Perhaps he would meet her many more times, but in our minds that naive and banal image was the only and the final one, and afterwards we saw only what we had never wanted to see, ever, until the last day of our lives.

And when we pushed away that other, bad vision, we felt good again and everything was a joy to us: the fire, the smell of trampled grass, that our shirts had dried, the sleep of the earth, the taste of cigarettes, the forest, our rested legs, the stardust, life – life most of all.

In the end, we went on. The dawn met us. The sun warmed us. We kept walking. Our legs buckled, our shoulders went numb, our hands swelled, but we managed to carry it to the cemetery – to the grave – our last harbour on earth, at which we put in only once, never again to sail forth – this Stefan Kanik, eighteen, killed in a tragic accident, during blasting, by a block of coal.

A Dispatch from Ghana

The fire stood between us and linked us together. A boy added wood and the flames rose higher, illuminating our faces.

'What is the name of your country?'

'Poland.'

Poland was distant, beyond the Sahara, beyond the sea, to the north and to the east. The *Nana* repeated the name aloud. 'Is that how it is pronounced?' he asked.

'That's the way,' I answered. 'That's correct.'

'They have snow there,' Kwesi said. Kwesi worked in town, in Kumasi, and he had come here on vacation. Once, on the movie screen, snow had fallen. The kids applauded and cried merrily, '*Anko! Anko!*' asking to see the snow again. That was great – the white puffs fell and fell. Those are lucky countries. They do not need to grow cotton: the cotton falls from the sky. They call it snow and they walk on it and even throw it into the river.

We were stuck there by chance. The driver, my friend Kofi from Accra, and I. It was already dark when the tyre blew – the third tyre, rotten luck. It happened on a side road, in the bush, near the village of Mpango in Ghana. Too dark to fix it. You have no idea how dark the night can be. You stick out your hand and you cannot see that hand. Here they have nights like that. We walked into the village.

The *Nana* received us. There is a *Nana* in every village, because *Nana* means boss, head man. The head man is a sort of village mayor but he has more authority. If you and Maryna want to get married back home the village mayor cannot stop you, but the *Nana* can. He has a Council of Elders. These old guys meet, govern, ponder disputes. Once upon a time the *Nana* was a god. But now

there is the independent government in Accra. The government passes laws and the *Nana* has to execute them. A *Nana* who does not carry them out is acting like a feudal lord and they get rid of him. The government is trying to make all *Nanas* join the party, and many *Nanas* are the secretaries of their village party organizations. In such cases the party dues always get paid because the *Nana* takes them out of people's taxes.

The *Nana* from Mpango was skinny and bald, with thin Sudanese lips. Kofi presented us: my driver and me. He explained where I was from, and that they were to treat me as a friend.

'I know him,' Kofi said. 'He's an African.'

That is the highest compliment that a European can receive. It opens every door for him.

The *Nana* smiled and we shook hands. You always greet a *Nana* by pressing his right hand between both of your own palms. This shows respect for him. He sat us down by the fire, where the elders were just holding a meeting. He said boastfully that they met often, which did not sound strange to me. This bonfire was burning in the middle of the village and to the left and right, along the road, other fires were burning. As many fires as huts, because there are no kitchens in the huts and people need to cook. Perhaps twenty. So the fires, the moving figures of women and men, and the outlines of the clay huts were visible, all immersed in the depths of a night so dark that it felt like a weight, oppressive.

The bush had disappeared, yet the bush was everywhere; it began a hundred metres away, an immobile massiveness, a tightly packed coarse thicket surrounding the village, and us, and the fire. The bush screamed and cried, it stamped and crackled, it was alive, it existed, it bred and gnawed, it smelled of wilted greenery, it terrified and tempted, you could touch it and be wounded and die, but you couldn't look at it; on this night you couldn't see it.

Poland.

They did not know of any such country.

The elders looked at me uncertainly or suspiciously; some of them were interested. I wanted to break their mistrust somehow. I did not know how and I was tired.

'Where are your colonies located?' the *Nana* asked.

My eyes were closing, but now I regained consciousness. People often asked that question. Kofi had asked it first, long ago. I explained it to him. It was a revelation to him and from then on he always lay in wait for the question about the Polish colonies so that he could make a concise speech demonstrating its absurdity.

Kofi answered: 'They don't have colonies, *Nana*. Not all white countries have colonies. Not all whites are colonialists. You have to understand that whites often colonized whites.'

That sounded shocking. The elders shuddered and smacked their lips: tsk, tsk, tsk. They were surprised. In the past, I would have been surprised that they were surprised. But not any more. I can't bear that language, that white, black, yellow. The myth of race is disgusting. What does it mean? Because somebody is white, is he more important? So far, the majority of scoundrels have had white skin. I cannot see how anybody is either happy or upset about being this or that. Nobody gets to choose. The one important thing is the heart. Nothing else counts.

Kofi explained later: 'For a hundred years they taught us that the white is somebody higher, super, extra. They had their clubs, their swimming pools, their neighbourhoods. Their whores, cars, and their burbling language. We knew that England was the only country in the world, that God is English, that only the English travel around the globe. We knew exactly as much as they wanted us to know. Now it's hard to change.'

Kofi and I stuck up for each other, we no longer spoke about the subject of skin, but here, among new faces, the matter had to come up.

One of the elders asked, 'Are all the women in your country white?'

'All of them.'

'Are they beautiful?'

'They're very beautiful,' I answered.

'Do you know what he told me, *Nana*?' Kofi interjected. 'That when they have their summer, their women take off their clothes and lie in the sun to get black skin. The ones that become dark are proud of it, and others admire them for being as tanned as Negroes.'

Very good! So, Kofi, you hit the bull's eye! You got to them. The elders' eyes lit up at the thought of those bodies darkening in the sun, because – you know how it is – men are the same all over the world: they like that sort of thing. The elders rubbed their hands together, smiled; women's bodies in the sun; the fire here was driving away their rheumatism; they snuggled up inside their loose *kente* robes modelled on Roman togas.

'My country has no colonies,' I said, 'and there was a time when my country was a colony. I respect what you've suffered, but we had it horrible: there were trams, restaurants, districts *nur für Deutsch*. There were camps, war, executions. You don't know camps, war and executions. That was what we called fascism. It's the worst colonialism.'

They listened, frowning and closing their eyes. Strange things had been said, which they had to digest. Two whites and they could not ride in the same tram.

'Tell me, what does a tram look like?'

The concrete is important. Perhaps there was not enough room. No, it had nothing to do with room; it was contempt. One person stepping on another. Not only Africa is a cursed land. Every land can be like that – Europe, America, many places in the world. The world depends on people. Of course, people fall into types. For instance, a person in the skin of a snake. A snake is neither black nor white. It is slippery. A person in a slippery skin. That is the worst.

'But *Nana*, we were free afterwards. We built cities and ran lights into the villages. Whoever couldn't, learned how to read.'

The *Nana* stood up and grasped my hand. The rest of the elders did the same. Now we were friends, *przyjaciele*, *amigos*. I wanted to eat. I could smell meat in the air. There was no scent of jungle, of palm, or of coconuts, but only of our sausage that costs 11.60 złoty at an inn, in the Mazury. And a large beer.

Instead of that, we ate goat.

Poland –

– snow falling, women in the sun, no colonies, there had been a war, building homes, somebody teaching somebody to read.

At least I had told them something, I rationalized inwardly. It's too late to go into details, I want to go to sleep, we are leaving at dawn, staying to deliver a lecture is impossible.

Suddenly I felt shame, some sort of shortcoming, a sense of having missed the mark. What I had described was not my country. Now, snow and the lack of colonies – that's accurate at least. But it is nothing, nothing of what we know, of what we carry around within ourselves without even wondering about: nothing of our pride and despair, of our life, nothing of what we breathe, of our death.

So, snow – that's the truth, *Nana*, snow is marvellous and terrible, it sets you free with your skis in the mountains and it kills the drunkard lying by the fence. Snow, because January, the January 1945 offensive, ashes, everything in ashes: Warsaw, Wrocław, and Szczecin, a brick, a brick, freezing hands, warmth-giving vodka, people laying bricks, this is where the bed will stand, and the wardrobe right here, people filtering back into the centre of the city, ice on the windowpanes, ice on the Vistula, no water, holidays at the waterside, at the seashore, the sand, the woods, the heatwave, sand, tents and Mielno, I'm sleeping with you, with you, with you, somebody's weeping, not here, it's deserted and it's night so I'm crying, those nights, our meetings till dawn, tough discussions, everybody having his say, Comrades! the sky lit up and the stars, because Silesia, blast furnaces, August, seventy degrees Celsius in front of the blast furnaces, the tropic, our Africa, black and hot, hot sausage, why did you give me a cold one, hang on friend, is this your solo, not jazz, but a speech, Sienkiewicz and Kurylewicz, cellars, damp, the potatoes are rotting, get a move on, woman, and turn those spuds over, the market women at Nowolipki, keep moving along, there are no miracles, what do you mean there aren't, what a lovely little war, shut up about the war already, we want to enjoy things, to be happy, I'll tell you something, you are my happiness, an apartment, a television, no, a motorcycle first, the noise when it revs, the children in the park wake up instead of sleeping, what air, not a cloud in the sky, no turning back, if Herr Adenauer thinks, too many graves, we can fight and we can drink so why

can't we work, unless we learn how, our ships are sailing on every sea, successes in exports, successes in boxing, youngsters in gloves, wet gloves pulling tractors out of the mud, Nowa Huta, we have to build, Tychy and Wizów, cheery bright apartment houses, up with the country, upward mobility, a cowherd yesterday and an engineer today, sliding through the polytechnic, do you call that an engineer, and the whole tram bursts out laughing (tell me what a tram looks like), it's very simple: four wheels, an electrical pick-up, enough already, enough, it's all a code, nothing but signs in the bush, in Mpango, and the key to the code is in my pocket.

We always carry it to foreign countries, all over the world, to other people, and it is the key of our pride and our powerlessness. We know its configuration, but there is no way to make it accessible to others. We'll never get it right, even when we really want to. Something, the most important, the most significant thing, will remain unsaid.

Relate one year of my country, it does not matter which one, let us say 1957, just one month of that year, take July, just one day, let us say the sixth.

No way.

Yet nevertheless that day, month and year exist in us, they have to exist, because after all we were there, we were walking along the street, we were digging coal, we were cutting the forest, we were walking along the street, and how can you describe one street in one city (it could be Kraków) so that they can feel its movement, its atmosphere, its persistence and changeability, its smell and its hum, so that they can see it?

They cannot see it, nothing can be seen, the night, Mpango, the dense bush, Ghana, they're putting out the fires, the elders are going off to sleep and so are we (departure at dawn), the *Nana* is dozing off, snow is falling somewhere, women like Negroes, he thinks, they are learning to read, he said something, the *Nana* thinks, they had a war, whew, a war, he said, yes, no colonies, no colonies, that country, Poland, white and they have no colonies, he thinks, the bush screams, what a strange world.